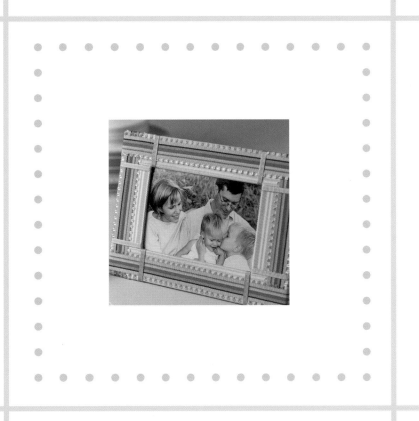

Fun with
Family Photos

crafts • keepsakes • gifts

by
jennifer barry

with contributing project designs by
leslie barry

photographs by caroline kopp

TEN SPEED PRESS
Berkeley • Toronto

Ten Speed Press
Box 7123
Berkeley, California 94707
www.tenspeed.com

Distributed in Australia by Simon and Schuster Australia, in Canada by Ten Speed Press Canada,
in New Zealand by Southern Publishers Group, in South Africa by Real Books, and in the United Kingdom
and Europe by Airlift Book Company.

Design, crafts, and styling by Jennifer Barry, Jennifer Barry Design, Fairfax, CA
Contributing craft projects design by Leslie Barry, Houston, TX
Photography by Caroline Kopp
Layout production by Kristen Wurz

Library of Congress Cataloging-in-Publication Data
Barry, Jennifer.
Fun with family photos : crafts, keepsakes, gifts / projects and text by
Jennifer Barry ; additional projects by Leslie Barry ; photography by Caroline Kopp.
 p. cm.
ISBN 1-58008-641-1 (paper with flaps)
1. Handicraft. 2. Photographs—Trimming, mounting, etc. 3. Gifts.
4. Souvenirs (Keepsakes) I. Title.
TT857.B37 2004
745.593—dc22
2004018912

Printed in China
First printing, 2004

1 2 3 4 5 6 7 8 9 10 — 08 07 06 05 04

Contents

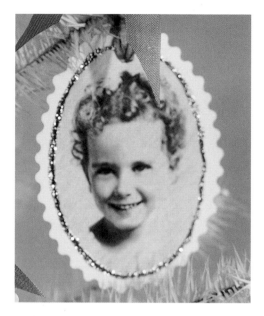

Fun with Family Photos contains dozens of ideas for making gifts and things for the home using family photos. Photography allows us to make a visual record of the life of our family. Whether black and white or in color, photographs are an important part of the way we preserve and document our family history. Instead of just putting your photo treasures behind glass in a frame, or leaving them tucked away in albums and boxes, you can use this book to learn how to transform your current or heirloom photos into wonderful personalized objects to enjoy and share with other family members.

Fun with Family Photos is divided into three chapters of photographic crafts: "Paperworks," projects such as cards and albums made with paper and card stock; "Frameworks," projects that explore creative ways to frame and mat family photos; and "Homeworks," decorative projects for the home such as place mats and desk accessories. Each project includes a list of the tools you will need and a thorough description of how to make it. Many of the projects include diagrammatic templates, which are shown in the back of the book; the materials used are listed by brand name and where they can be purchased in the Resources section.

Many of the creative ideas and methods in this book can be adapted to other projects. For instance, the Photo Place Cards on page 82 can also be used as gift enclosure cards. Or the design for the Family Who's Who Book on page 51 can be adapted to create a child's alphabet or spelling book. Once you become familiar with the tools and craft techniques, you can have fun experimenting with these new ways to surround yourself with photos of the ones you love.

*I*magine decorating your Christmas tree with beautiful handmade ornaments created from photos of your family. Or think of commemorating a family vacation with photos of your trip framed on a map of your destination or preserving them in a handmade album. Instead of traditional holiday cards, you could send friends and family "a year in the life" of your family on a photo CD packaged in a decorative handmade sleeve. Or send special friends their own photo desk calendar illustrated with favorite photos of themselves and their children, or photos of fun times you've spent together. These are a few of the personalized projects and gifts you will learn to create using this book, whether you're adept with a digital camera and personal computer or are a technological novice.

Getting Started: Helpful Hints

Here are some basic hints that will help make the projects in these pages go more smoothly. There are *specific* helpful tips throughout the book, but the list that follows is a general guide to what you should know about creating crafts with family photos. Also included is a description of the tools we've used and recommend.

1. Choose Black-and-White or Color: Whether your original photos are color or black-and-white, it's important to choose which way they will look best for each project. In this book, we show projects using both forms of reproduction. Remember, you can convert any color photo to black-and-white on a color or black-and-white copier machine, or with a personal computer. You can then hand color your copies with different mediums or create color and textural effects on the copier or computer as well.

2. Ask a Salesperson About New Tools or Materials: When shopping at art- and craft-supply stores, ask knowledgeable salespeople for information about a new craft tool or material that you are unfamiliar with. If you describe your project, they may be able to recommend brands of tools and supplies that will be suited to your needs. They may also be willing to demonstrate how to use a new tool to help make your project go more smoothly.

3. Practice with Your Tools and Materials: Before starting a project, if you are unfamiliar with a tool or material specified, practice using it on scrap paper first. You can even make a "mockup" of your project with scrap paper to test all your materials and tools.

4. Have Extra Materials on Hand: Always buy a little more of the materials called for in the list for each project, to allow for errors or design adjustments along the way.

5. Make Extra Copies of Your Photos: When making prints or copies of your final-sized photos on a color copier, inkjet printer, or high-quality photo print machine, always make extra copies to allow for errors or experimentation.

6. Use Photocopies, Not Originals: Whenever possible, work with copies of your heirloom photographs and preserve the originals in an acid-free archival box or album.

7. Practice Your Design: When decorating paper or other surfaces with rubber stamps, stickers, glitter glue, strips of type, hand punches, and other applied design elements, practice with your supplies on scrap paper to determine how you want your design to look before starting a project. You can cut up your practice scraps and move them around to determine a pleasing arrangement before making your final design.

8. Decide between Archival and Nonarchival: If you want your project to last a long time, use acid-free archival materials and archival-quality copies of your photos. If your project has a shorter shelf life, color copies and nonarchival materials will suffice and are more economically priced.

9. Experiment with Cropping Your Photos: After selecting the photo that you want to use for a project, take a moment to experiment with cropping it different ways to see how the composition changes and improves. You can make a set of simple cropping tools by cutting out two right-angle L-shaped pieces of black or white mat board that measure 2 by 10 inches. Move the tools around your photo, framing the image so that unwanted images in the background are cropped out, or cropping in tight on a portion of the photo. In the Photo Frame Pins project on page 56, we show how cropping the same photo three different ways changes the look of the pins. By selective cropping, you can strengthen the composition of your photo and make it more effective for your project.

Tools

Following is a brief description of the basic tools used for the projects in this book. They are divided into six categories: photographic reproduction tools, measuring tools, cutting and punching tools, adhesives, tapes and adhesive stickers, and additional tools. With the exception of the photographic re-production tools, all the tools listed here can be easily found at most art, craft, scrapbook, or drafting supply stores. Specific brands and types of tools used for each project, and where they can be purchased, are listed in the Resources section.

PHOTOGRAPHIC REPRODUCTION TOOLS

With the advent of personal computers and desktop publish-ing software, many of these photo craft projects are quite easy to produce. When appropriate, we've given instructions for how to produce a project using either a photocopier machine or a personal computer. If you decide to use a personal com-puter for a project, this book assumes you are already familiar with desktop publishing software such as Adobe InDesign and Photoshop, and the capabilities of your computer, scanner, and printing equipment.

Copier Machines: Black-and-white and color copiers come in a wide variety of models with a multitude of special copying functions. If a project calls for altering the color of a photo-graph, such as converting a color photo to black-and-white or making it sepia-toned or a hue of a single color, we recom-mend finding a copy shop that has machines that are accessible to customers and will allow you to experiment with different copying effects yourself, with an employee on hand to provide

mechanical assistance if needed. Most copy machines have multiple ways that paper can be fed through the machine. For several projects we instruct you to hand-feed a colored paper or cardstock through a copier. Make sure when using a copier at a copy shop that their copier can accept the kind of paper you want to use. Also, ask an employee what kind of copier papers they have available. There are multiple weights and finishes of copier paper available. (Note: For the projects using a color copier in this book, we used a Canon Model 900 color copier.)

Personal Computers, Desktop Publishing Software, and Color Inkjet Printers: Photographic copies and page layouts can be quickly and easily created using a personal computer and desktop publishing software. Page-design software such as Adobe Pagemaker and InDesign or Quark allows you to import digital scans of your photographs into your layout documents or templates; enlarge, crop, and move them around instantly; and then print them at a variety of sizes on different types of papers with a color or black-and-white inkjet printer. Photo-manipulation software such as Adobe Photoshop allows you to alter the color and texture of your photos for added effects and to digitally retouch photos that have been damaged over time or have unwanted composi-tional elements in the original frame. Now, with digital cameras, you can also download digital photos directly to a personal computer, thus eliminating the need for scanning equipment or film processing and printing services. Digital photos and photo scans can also be easily archived on the computer and/or stored and copied onto compact discs.

Photocopying Machines at Photo Film and Processing Stores:
High-quality copies of your photos can also be made on archival papers at photo film and processing stores and at professional photo labs. They are more costly than the previous two methods, but they have the archival advantage, as mentioned in "Helpful Hints." The photocopying machines at most film processing stores are "dye sublimation" machines that employ a thermal dye transfer process on photo paper to make photocopies. Because the dyes become heated and laminated to the surface of the paper, they are more long lasting and archival than prints from most inkjet printers. Be aware that you will not be able to dictate exact print sizes on the in-store machines as you can on a copier machine or personal computer. If you want archival quality and need to have photos exactly sized, you will have to have custom prints made to size at a photo film and processing store or professional photo lab.

MEASURING TOOLS

In this book, we use two different types of rulers and a proportion wheel for sizing photos and photocopies.

Cork-Backed Metal Ruler: This is the best ruler to use for measuring large sheets of paper and cardboard. It is an excellent non-skid straight edge to use for cutting these materials in combination with a craft knife. Cork-backed rulers come in a variety of lengths, and we recommend using either an 18-inch- or 24-inch-long ruler for these projects.

Schaedler Precision Ruler: This flexible 12-inch ruler is made of transparent Mylar and has ruler increments marked by hairlines to $1/32$ of an inch and also in millimeters. Found mostly at art supply stores, it is an excellent ruler for measuring very fine increments, and the transparent Mylar allows you to see through to the material you are measuring underneath. It cannot be used as a straight edge for cutting.

Proportion Wheel: This plastic circular tool is used for determining the proportion of enlargement or reduction of an image. It is made up of two different-sized disks that are stacked and fastened together at their center, each with inch increments printed along its circumference. After measuring your original image with a ruler, the innermost disk is used to plot the measurement of your original to its desired size as shown on the outermost disk, by rotating the disks so that the measurements align. The percentage of reduction or enlargement is shown in numeric form in a window on the inner disk. This tool is necessary for resizing images and templates for enlargement or reduction on photocopy machines and can be found at any art supply store.

CUTTING AND PUNCHING TOOLS

Virtually every project in the book requires using a self-healing cutting mat as the preferred surface for cutting with a variety of craft knives. Decorative-edged scissors and hand-punching tools come in a variety of designs as described below.

Self-Healing Mat: This is a hard, rubber $1/8$-inch-thick cutting mat that comes in a variety of sizes. We recommend using one that is at least 12 by 18 inches in size. The rubber surface allows you to cut on it with craft knives without leaving cut marks, thus maintaining a smooth cutting surface after each use. The mats can be purchased at craft and art supply stores.

Clear Plastic Triangles: Available at art and drafting supply stores, plastic triangles are available in a variety of sizes. While triangles can be used to draw varying angles for different shapes, in this book we use small 45-degree or 30/60-degree triangles as straight edges for making small cuts in tight corners with a craft knife. The transparent plastic allows you to see exactly where you're making the cuts, and to position them in a small space.

X-acto Knife: This craft knife is our preferred cutting tool for making clean, straight cuts. It has smaller blades than a large utility knife, thus allowing for smaller-precision cutting. The removable razor-sharp blades should be replaced often so that cutting remains precise.

Large Utility Knife: A large craft knife with a handle housing a retractable knife blade, this tool is better for making large cuts. Use on cardboard and mat board, or any heavy-weight board material.

Shaped Paper Punches: Metal paper punches come in a variety of designs, shapes, and sizes. From circular-hole punches to those with decorative shapes and letters, they are used to punch precise, clean-cut shapes in paper and lightweight card stock. When using a paper punch, always orient the tool "punching side up," so that you can see where you are placing the hole to be punched.

Decorative-Edge Scissors: These scissors come in a variety of different-shaped cutting edges, such as a zig-zag, scallop, deckle, and others. They are designed to be used on paper and lightweight card stock to create decorative paper edges.

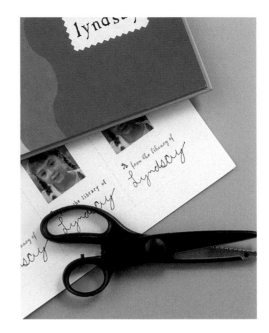

Some brands also offer large and small versions of the edge designs. The trick to using these scissors is aligning the shaped cuts of your decorative edge each time you cut. Practice on scrap paper before using on your craft project.

ADHESIVES

Choosing the best type of adhesive for each project is often a trial-and-error process. When using high-quality photos, always use adhesives that are acid-free so that they won't stain or discolor your photos over time. Color copies and inkjet prints that are less precious don't require acid-free materials.

Water-Based Liquid Craft Glues: There are many brands of water-based glues. Most dry clear, are fast-drying, and can be thinned with water. Craft glues are great all-purpose glues that can be used on paper, cardboard, wood, and fabric. If you

are using archival papers and materials, we recommend using acid-free bookbinding glue that can be applied from the applicator on the bottle or with a brush or sponge. Once you apply the glue to paper and position it on another surface, you cannot reposition the paper or photo. Do not use water-based glues on papers or prints that are water sensitive or that have inks that may bleed when wet.

Water-Based Dimensional Adhesive: This water-based, liquid glue is acid-free and can be used on paper and photos to glue them to other surfaces. It is slightly viscous and can be thinned with water and brushed on, or used in its original consistency to make a raised, transparent shield on top of a photo or object. It is slower drying than craft glues, with a slightly mottled surface like a glaze. It can also be used on wood, metal, ceramics, and glass.

Wood Glue: Similar to craft glue, wood glue is a pale yellow water-based glue made especially for gluing wood together. When it dries it has a slightly yellowish appearance but is invisible on most wood surfaces.

Water-Based Sealer (Mod Podge découpage matte medium): This quick-drying, water-based white gel is used to adhere and seal paper, cardboard, and fabric to a variety of surfaces such as wood, canvas, cardboard, and metal. Applied with a brush, it appears opaque at first but dries clear with a matte finish. Several coats can be layered on top of each other to form a permanent waterproof seal. The surface can also be sanded smooth between coats, if desired.

Repositioning Adhesive (Two-Way Glue): This is a semi-dry adhesive that is dispensed from a handheld applicator. The adhesive is brushed onto the back of the paper to be applied; if allowed to dry, the paper can be easily lifted and reposi-tioned several times. If the paper is applied and adhered while wet, the glue forms a permanent adhesive seal and the paper cannot be repositioned. The applicators come in various-sized widths so that you can select a narrow tip for small areas or a wide tip for larger areas of coverage. This adhesive is a favorite of scrapbook makers and can be found at scrapbook supply stores.

Multipurpose Cement: This super-bonding, clear liquid cement comes in a tube and is used for bonding metals, glass, ceramics, plastics, and wood to other materials. It should not be used for paper and the fumes are slightly noxious. It is slow-drying and should be used carefully according to the manufacturer's instructions.

Spray Adhesive: This adhesive comes in an aerosol can and is sprayed to the back of paper, photos, and fabric surfaces to allow them to be adhered to other paper or cardboard sur-faces. Unlike liquid glues, this semi-dry adhesive will not cause paper or photos to buckle from the moisture in the product. It comes in a variety of adhering strengths, and there is even an acid-free variety especially for photos. It should be used in a well-ventilated, wind-free space, and items to be sprayed should be placed on a large clean sheet of disposable paper or cardboard to eliminate the adhesive being sprayed onto surfaces where unwanted. The lower-tack varieties allow you to reposition items after the adhesive is applied.

TAPES AND ADHESIVE STICKERS

While adhesive tapes are available in a wide variety of types, we have found those in the following list to be the most useful for the projects in this book. Adhesive photo corners used for mounting photos to paper materials are also available in a variety of designs and are described below.

Double-Stick Tape: This clear cellophane tape comes in a dispenser and is coated with an adhesive on both sides. It comes in $\frac{1}{2}$-inch widths but is also available from some manufacturers in large sheets with a removable paper backing. Tape is used in place of glues to adhere paper or fabric materials together when using wet glue is not desirable. It is not acid-free and should not be used to mount archival-quality photos to surfaces

Drafting Tape: This tape looks like standard buff-colored masking tape, but has a low-tack adhesive backing. The backing enables the tape to be pulled up after use and not tear the paper it has been adhered to. Commonly used for drafting and graphic production, it comes on a roll in various widths and is great for anchoring in place paper, photos, or paper templates that need to be traced or carefully trimmed.

Acid-Free Paper Tapes: This archival, acid-free paper tape is commonly used by framers and museums to mount photos and artwork to mat board. It has a dry adhesive on one side that must be moistened slightly to activate the tacky surface. Framers usually make a folded paper hinge out of this tape and place small pieces of it on the back corners of photos and art to be mounted.

Acid-Free Photo Adhesive Stickers: These archival-quality, acid-free clear stickers have a double-sided adhesive and come in a dispenser. They are precut into $\frac{1}{2}$-inch-square stickers that can be used to mount photos, much like double-stick tape. Once adhered to a paper surface they cannot be repositioned and they hold photos or paper ephemera firmly in place.

Acid-Free Photo Corners: These archival-quality, acid-free corners have a dry adhesive backing and are used to mount photos or paper ephemera only at their corners to other paper surfaces. There are paper varieties that come in different colors and must be moistened on the back to adhere to a surface. There are also clear plastic varieties that do not need to be moistened and come with a tacky adhesive backing with a removable paper lining. In both cases, photos or artwork slide into the corners and are then positioned and adhered to a surface. Once adhered, they cannot be repositioned. The paper varieties have been around for many decades and now lend a vintage look to photo albums and projects when used.

ADDITIONAL TOOLS

Many of the projects in this book require the additional tools described below.

Bone Folder: A 1 by 7-inch flat bookbinding tool that is tapered at one end. It is used for making smooth creases and folds on paper and card stock, and sometimes to burnish large areas smooth. By running the tapered end against a ruler, while using pressure to make a narrow groove, it can

also be used to score paper and card stock, which facilitates clean, straight folds. Originally carved from bone, they are now also made from molded plastic and are found at art, craft, and scrapbook-supply stores.

Burnisher: A 7-inch plastic or metal stylus-shaped tool used to burnish and position letter stickers, press type, and other small decals or stickers to surfaces with precision. Some burnishers come with a flat, plastic ⅝-inch-wide end that can be used like a bone folder for making creases or burnishing larger surface areas. They can be found at art, craft, and scrapbook-supply stores.

Stamping and Embossing Powders: Fine-grain metallic or opaque-colored powders used in conjunction with special transparent ink pads. Stamping powders are used to make iridescent stamp impressions on paper or card stock. A rubber stamp is pressed onto the transparent ink pad, and pressed onto paper; then the impression is coated with a small amount of powder, which adheres to the inked area. Excess powder is blown or gently brushed away, leaving an iridescent stamped impression.

Embossing powders are applied in the same way, but after the powder is applied and the excess brushed away, the impression is then heated with an embossing heat tool, which melts the powder, creating a permanent, raised effect like embossing. Both types of stamping powders and the heat tool can be found at craft- and scrapbook-supply stores.

Embossing Heat Tool: A gun-shaped, electric hand-held heat dispenser that is used to melt embossing powder.

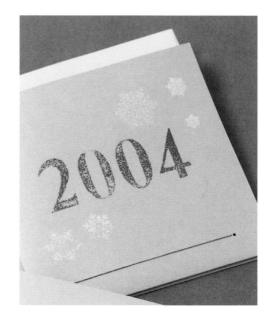

Now that you have become familiar with the tips and tools we've discussed, we hope this book will inspire you to find new ways to use your family photos. Remember, you don't have to be a professional photographer to create lasting mementos of your loved ones. Just roll up your sleeves and have fun exploring some of the creative possibilities in *Fun with Family Photos*.

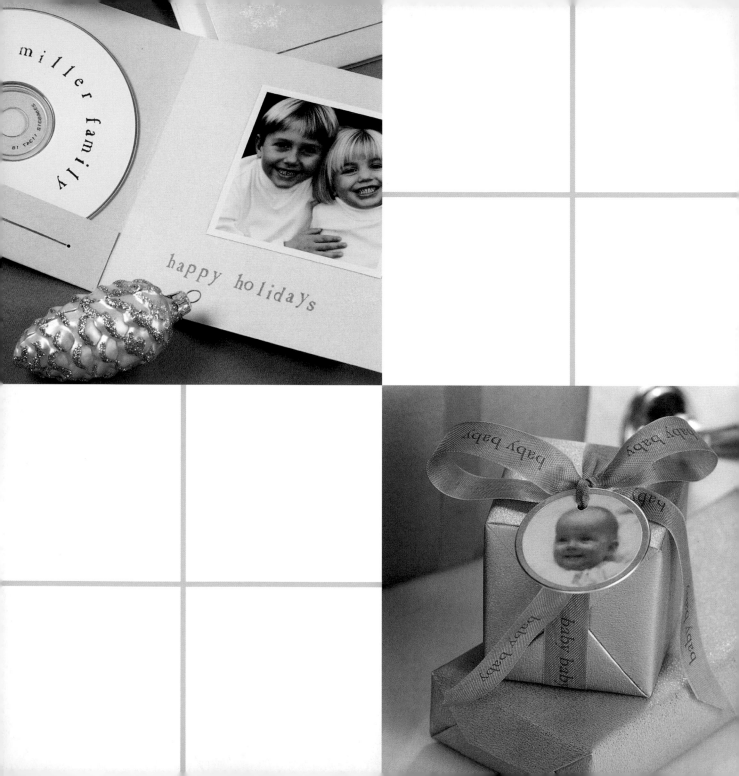

Paperworks

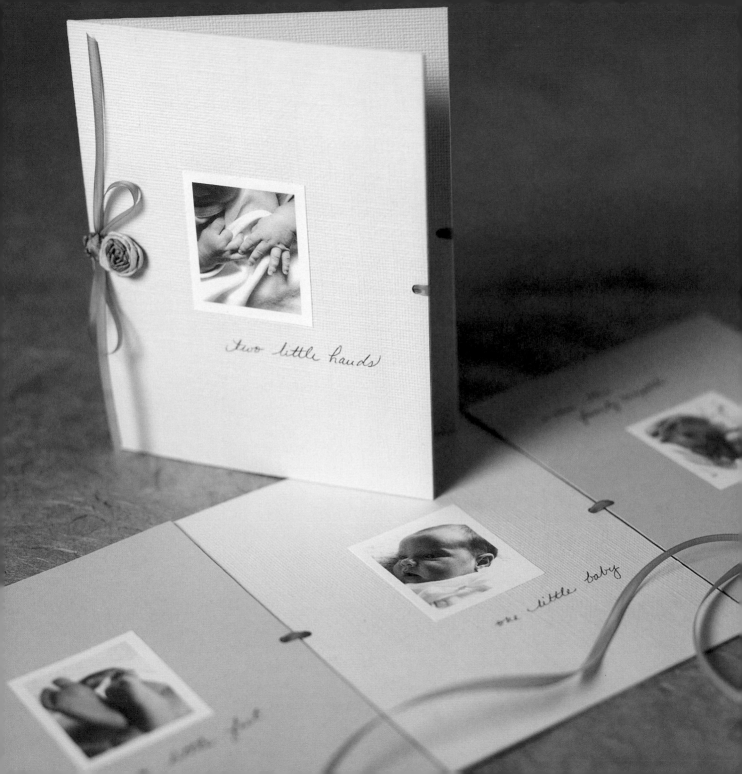

two little hands

one little baby

Photo Birth Announcement

"Two little hands / two little feet / one little baby / makes this family complete" is the message for this loving photo birth announcement, illustrated by soft black-and-white photos of the new baby's hands, feet, and face. The card is made with alternating colors of card stock, printed from a handwritten template on a copy machine. Bound together by tiny ribbon, it makes a lovely personal announcement for your family's newest arrival.

You will need:

Metal ruler

Pencil

X-acto knife

Self-healing cutting mat

Four 4 by 6-inch vertical photos: baby's hands, baby's feet, baby's face, and baby with family

2 sheets of 8½ by 11-inch white bond paper

Acid-free glue stick

Black-and-white copy machine

Black pen

Sheets of 8½ by 11-inch card stock in 2 different colors; allow 1 sheet of each color per card (you will get 2 cards from every pair)

⅛-inch-diameter hole punch

⅛-inch-wide ribbon; allow 24 inches per card

All-purpose cement

Small ribbon flowers, 1 per card (available at fabric stores)

4⅜ by 5¾-inch envelopes for mailing

To make:

1. Using the ruler, pencil, X-acto knife, and self-healing cutting mat, measure and crop the tops and/or bottoms of the photos so that they measure 4 by 4¾ inches.

2. Place them on a sheet of white bond paper, aligning them in a perpendicular quadrant and allowing ¼ inch of space between each photo and ¼-inch margins.

3. Using the glue stick, apply a small amount of glue to the backs of the photos to secure them in place on the paper.

4. Place the bond paper with the mounted photos on the black-and-white copier and make a reduced copy at 32 percent. (You will need one copy of the photos for each card.) Experiment with the light and dark settings on the copier to achieve soft, light copies of your photos. Be sure to make 1 copy of the photo quadrant for each announcement.

5. Trim the photos using a ruler and X-acto knife, leaving a ⅛-inch white border around each photo.

6. To make the text template for the announcement, take the other sheet of bond paper and draw light pencil lines dividing it into an equal quadrant.

7. Use the pen to write the first 3 lines of text for the announcement in 3 of the quarters, positioning your lines 1¼ inches from the bottom and ¾ inch from the right side

of each quarter. In the fourth quarter, write the last 2 lines of the announcement in the upper left of the quarter, ¾ inch from the top and left side. In the bottom right of the same quarter, write the baby's name, birthdate, and weight on 3 lines, ⅝ inch from the bottom and right side.

8. Place the bond paper text template on the copy machine and hand feed the 2 different sheets of colored card stock into the machine, making 2 copies of the text.

9. Using the X-acto knife and ruler, trim each sheet of card stock into 4 equal single cards. Use alternating colors of cards for each of the 4 panels of each announcement. (You can use the remaining set of cards for another announcement.)

10. Glue the 4 trimmed photos to each card panel with a glue stick, positioning the photo above each line of text in the center of each panel.

11. Using the hole punch, make 2 holes in the sides of each panel, ⅛ inch from either side and centered top and bottom. (Helpful hint: After positioning and punching the first panel, lay it on top of another panel and use it as a guide to position the holes in the same place for each panel.)

12. Lay the 4 panels in a long row in the correct reading order.

13. Beginning with the first card, thread the ribbon through the left-hand hole from front to back, then back through the hole on the right side. Repeat for the next panels, threading all 4 panels together.

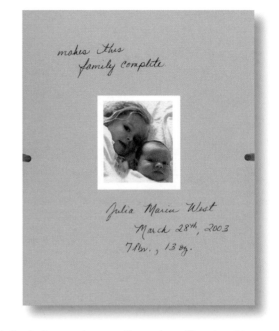

14. Stack the panels accordion style, pulling the ribbon taut, and tie the loose ends together first in a knot and then in a bow positioned tightly on the left side of the stacked panels. The card is now bound by the ribbon and will open on the right, with photos and text on each panel.

15. To finish, place a small dot of all-purpose cement on the front of the card next to the knotted bow and attach a small ribbon flower as a decoration. Insert in envelopes to mail.

Birthday Invitation

The birthday child is pictured as one of the "little creatures" that decorates this insert card and sleeve-style invitation for a nature-themed party. All the creatures are hand-punched photocopy labels that you can easily make on a color copier using label paper.

You will need:

Black-and-white copy machine

Metal ruler

Proportion wheel

Colored stickers of 4 different insects, animals, sea creatures, or other creatures, depending on the theme of your party

Photograph of the birthday child

3 sheets of 8½ by 11-inch white bond paper

Color copier

Scissors

Glue stick

8½ by 11-inch full sheets of white laser printer labels (available at office supply stores)

X-acto knife

Self-healing cutting mat

1-inch-diameter circle punch (available at craft supply stores)

Pencil

Rubber letter stamps and ink pad

Sheets of 8½ by 11-inch colored card stock (allow 1 sheet for each invitation sleeve)

Sheets of 8½ by 11-inch card stock in another color (1 sheet will yield 3 invitation insert cards)

¹⁄₁₆-inch-diameter hole punch

Raffia (available at craft supply stores)

Small twigs, about ⅛ by 4½ inches (1 for each invitation)

4⅛ by 9½-inch envelopes (No. 10 size) for mailing

To make:

1. Make a black-and-white copy of the printing sticker template on page 102 at 200 percent on a copy machine.

2. Using the ruler and proportion wheel, measure the creatures on the stickers and the head of the child in your photograph to determine the sizes of enlargement or reduction so that each will fit comfortably inside a 1-inch-diameter circle. (You will make multiple copies of your resized creatures to place on the printing sticker template later.)

3. Using the color copier, make 7 copies of each different creature and the child at the predetermined sizes. (Alternatively, you can economize the number of copies you will need by sticking multiple stickers of the same creature, if available, onto a sheet of bond paper and making your color copies at the predetermined sizes so that you end up with 7 of each creature.)

4. Using scissors, loosely cut out the copies of the creatures. Cut the copies of the child into approximate 1¼-inch squares.

5. To assemble your master printing sticker template, use a glue stick to glue the color copies of each of the creatures and the child in one of the top 5 squares of the template starting in the first horizontal row. Repeat for the other rows.

6. Place the finished template in a color copier and hand-feed sheets of laser label stock into the copier to make sheets of creature/child labels. (Each sheet will yield enough labels for 7 invitations.)

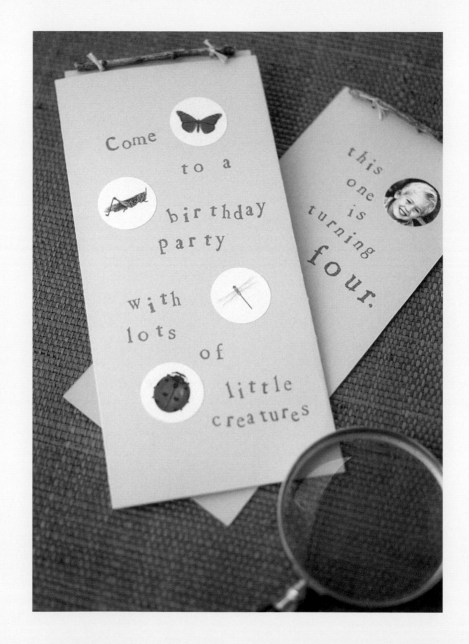

Birthday Invitation (continued)

7. Following the template grid lines on the copies, cut out the horizontal rows of labels in strips with the X-acto knife, ruler, and cutting mat.

8. Punch out circular labels of each creature and child from the strips with the 1-inch-diameter circle punch.

9. To make a printing template for the card sleeve, take a sheet of white bond paper and turn it horizontally. Using the ruler and pencil, divide the sheet into three sections: The left- and righthand sections should measure 3½ by 8½ inches; the center section should measure 4 by 8½ inches. Draw light pencil marks at the top and bottom edges of each section. (These will be your folding guides when the template is copied onto card stock.)

10. In the middle section, use letter stamps to stamp the birthday message as shown in the photograph. Be sure to leave 4 areas near the lettering where the circular creature labels will be placed later.

11. To make a printing template for the insert card, take another sheet of bond paper and turn it horizontally. Using the ruler and pencil, divide the sheet into three equal sections measuring 3⅝ by 8½ inches. Draw light pencil marks at the top and bottom edges of each section. (These will be your trimming guides when the template is copied onto card stock.)

12. Using the letter stamps, stamp the remaining message of the invitation—"this one is turning four" (insert the correct age of the child)—at the top of the left section of the template. (See the photograph of the finished insert card at left.). Be sure to leave an area to the right of the text where the circular photo portrait label will be placed later. Stamp the party date, time, place, and RSVP information at the bottom of the section. Repeat the stamping in the remaining two sections of the template.

13. Using the black-and-white copier and the card sleeve and insert card templates, make copies of the 2 templates on different-colored card stock. You will need 1 sleeve and 1 insert card for each invitation. (Note: You will get 3 insert cards per 8½ by 11-inch sheet after they are trimmed.)

14. To assemble the sleeve, fold back the side sections of the printed sleeve card at the penciled fold marks and crease the folds with your fingers.

15. Using the glue stick, glue the sleeve flaps together with a line of glue on the back edge of the outer flap and a line of glue on the front edge of the inner flap. Repeat for all the other sleeves.

16. To assemble the insert cards, use the X-acto knife, ruler, and cutting mat to trim the 3-per-sheet cards along the pencil mark guidelines. Use the 1/16-inch-diameter hole punch to make 2 holes as close to the top edge of the insert cards as possible and ½ inch from either side.

17. To attach the twig handle at the top of the card inserts, thread a small length of raffia through each hole, place a twig on top of the card, and knot the raffia around the twig. Cut the excess loose ends with scissors. Repeat for all the cards.

18. To finish the sleeves and insert cards, remove the backing from the labels and place creature labels on the sleeves and the portrait labels on the inserts as shown in the photograph. Insert the finished cards into the sleeves and then into the envelopes to mail.

Family Moving Announcement

Let your friends and family know you've moved with this house-shaped moving announcement starring pictures of the whole family.

You will need:

Black-and-white copy machine

Metal ruler

X-acto knife

Self-healing cutting mat

Pencil

Sheets of 8½ by 11-inch colored card stock, 1 sheet for
 each announcement

Key-shaped craft punch (available at craft and scrapbook
 supply stores; optional)

Proportion wheel

Close-up photos of each family member

Glue stick

¼-inch-high letter stamps and ink pad

Sheets of 8½ by 11-inch ivory-colored card stock,
 1 sheet for each announcement

1-inch-high letter stamps and ink pad

5½ by 7½-inch envelopes for mailing

To make:

1. Using the copy machine, enlarge the house and window templates on page 103 by 200 percent. Cut out only the house template using the ruler, X-acto knife, and cutting mat.
2. Trace the house template onto sheets of colored card stock with a pencil and trim the cards using the X-acto knife, ruler, and cutting mat.
3. Fold the house cards in half at the center line and use the key-shaped craft punch to punch a small key at the top of the roof of each card on the front side only.
4. Using the copy of the enlarged window template, size your family portraits to fit inside the inner lines of the windows by using the ruler and proportion wheel to measure each portrait and determine the percentage of enlargement or reduction necessary to fit in the windows.
5. Make a black-and-white master copy of each portrait at the predetermined size, and trim the copies to fit inside the template window using the X-acto knife and ruler.
6. Using the glue stick, glue the portraits in place on the window template.
7. In the extra space on the template next to the windows, stamp out your family's name and new address on several lines with the small letter stamps and inkpad. Using the pencil and ruler, draw a rectangle around the text to use as a cutting guide.
8. Make multiple copies of the template on the ivory card stock with the copier, making one for each announcement.
9. Using the X-acto knife, ruler, and cutting mat, cut out the portrait windows with their borders along the outer window guidelines, then cut out the name/address cards.
10. Glue the windows to the front of each house card as shown in the photograph, using the glue stick. Inside the card, glue the name/address cards on the left-hand panel.
11. On the inside right-hand panel, using the large letter stamps and ink pad, spell out "we've moved." Insert the finished cards into envelopes to mail.

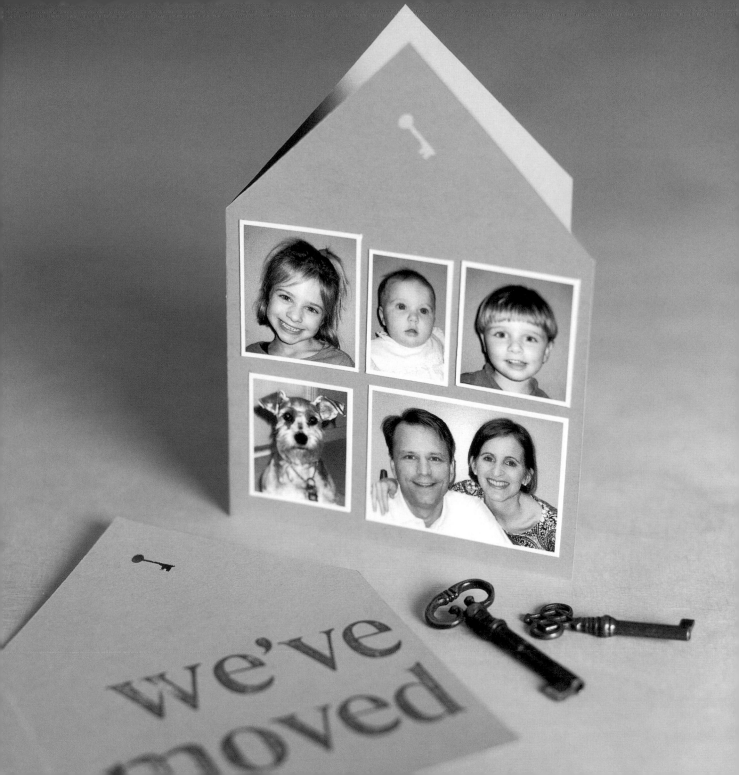

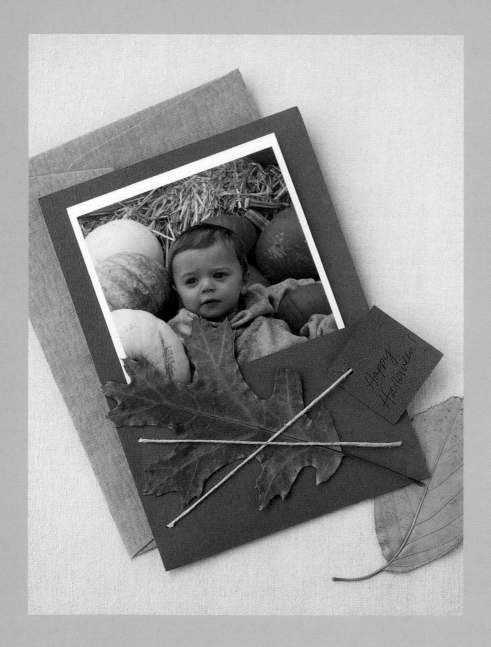

Photo Pocket Card

This simple pocket card is a lovely way to package a group of family photos to share with family and friends. If your photos have a holiday theme, you can tuck dried leaves or flowers in with the photos to make a colorful seasonal greeting, as shown here.

You will need:

Sheets of 8½ by 11-inch colored card stock (allow 1 sheet per pocket card)

Metal ruler

Pencil

X-acto knife

Self-healing cutting mat

Bone folder

1/16-inch-diameter hole punch

Waxed twine (available at craft and scrapbook supply stores)

Scissors

4 by 6-inch photographs

Pen

Pressed dried leaves or flowers

5½ by 7½-inch envelopes for mailing

To make:

1. With a sheet of card stock in an upright, vertical orientation, use the ruler, pencil, X-acto knife, and cutting mat to measure and trim off a 1-inch-wide strip from the bottom of the sheet and a 3½-inch-wide strip from one of the sides. The card should now measure 5 by 10 inches.

2. With the sheet still in a vertical orientation, measure 3 inches up from the bottom and draw a light pencil line across the width of the card for the pocket flap. Score along the pencil line with the ruler and bone folder.

3. Fold up the pocket flap at the score line and crease the fold firmly with the bone folder.

4. To bind the pocket flap at the sides of the card, use the ruler and pencil to measure and mark the position for 4 twine holes that are ¼ inch from each side and ⅝ inch from the top and bottom of the flap.

5. Punch holes at pencil marks with the hole punch.

6. Measure and cut a length of twine 16 inches long.

7. Turn the card over so that the flap is on the underside and thread the twine through the top right hole. Pull it diagonally across the pocket flap and thread it through the bottom hole on the opposite side. Pull the twine up and thread through the top hole on the same side, then diagonally across the pocket flap again, and out through the bottom right hole. Pull the loose ends taut, and tie them in a small knot. Trim the loose ends close to the knot with scissors.

8. To make a small enclosure note, trim a small 1 by 1-inch square out of the excess card stock with the X-acto knife and ruler. Punch a hole in one corner with the hole punch and cut a diagonal slit from the hole to the corner so that the note can slide onto the twine pocket binding.

9. Write an enclosure greeting on the note with a pen, load the pocket card with the photographs, and finish by slipping pressed leaves or flowers between the twine binding on the pocket and into the pocket itself, if desired. Insert the finished cards into envelopes to mail.

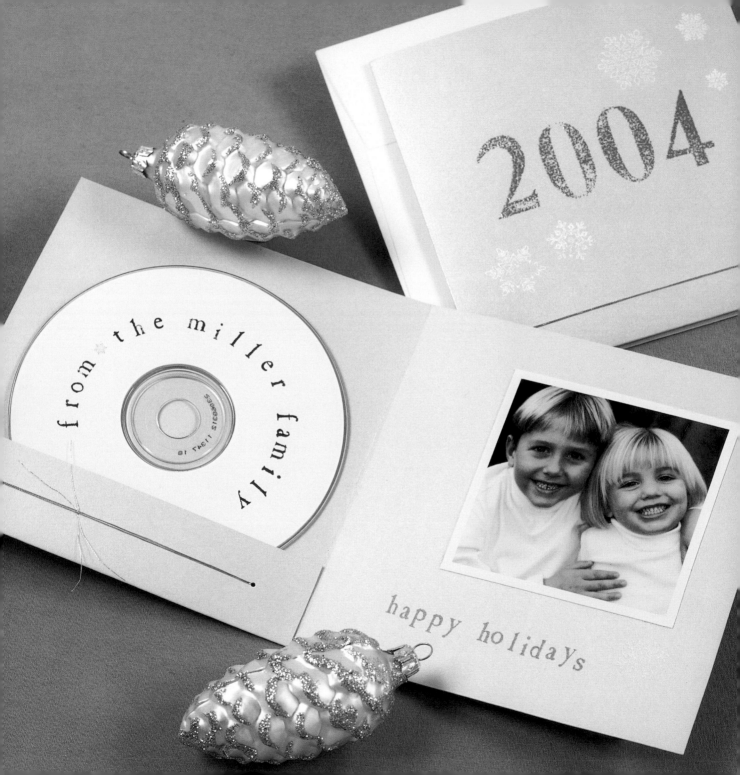

Holiday Photo CD Card

With the advent of digital cameras and photo-storage discs, photo CDs have become a popular way to save and share personal photo collections. Here, we've created a holiday card using embossing powders and rubber stamps that comes packaged with a family photo CD.

You will need:

A set of cardboard cropping tools (see page 7, "Getting Started," step 9)

$3\frac{1}{2}$ by 5-inch or 4 by 6-inch family photo (choose one whose composition allows the photo to be cropped into a square)

Metal ruler

1 sheet of $8\frac{1}{2}$ by 11-inch white bond paper

Pencil

X-acto knife

Self-healing cutting mat

Removable drafting tape

Proportion wheel

Color or black-and-white copier, or high-quality photocopying machine (found at photo film and processing stores)

Sheets of $8\frac{1}{2}$ by 11-inch colored card stock (allow 1 sheet per card)

Bone folder

$\frac{1}{16}$-inch-diameter hole punch

Spool of very thin silver metallic thread or string

Scissors

Rubber number stamps

Embossing stamp pad (available at craft supply stores)

Silver and clear embossing powder (available at craft supply stores)

Small soft-bristle paintbrush

Embossing heat tool (available at craft supply stores)

Rubber snowflake stamps

Glue stick

Rubber letter stamps

Gray ink pad

Precut white CD labels (available at office-supply stores)

6-inch-square envelopes for mailing

To make:

1. Using the cropping tools, crop your photo into a square. Measure the aperture of the square with the ruler.

2. On a piece of bond paper, use the ruler, pencil, X-acto knife, and cutting mat to measure, draw, and cut out a square the same size as the aperture of the cropped photo. Discard the square.

3. Place the bond paper frame over the photo positioning the cutout window over the photo in the predetermined cropped position. Attach the photo to the paper with small pieces of drafting tape on the back side.

4. Using the ruler and proportion wheel, determine the size of enlargement or reduction necessary to make finished copies of your photo that are approximately 3 inches square.

5. If using a color or black-and-white copier, make multiple copies of the photo with its bond paper frame at the

predetermined size, allowing 1 photo for each card. Alternatively, if you are using a photocopying machine at a film-processing store, make multiple copies of your photo with its bond paper frame at the predetermined size using the machine software available.

6. Using the X-acto knife, ruler, and cutting mat, trim out all the photos, leaving a 1/8-inch white border on all sides.

7. Using a black-and-white copier, make an enlarged copy of the card template on page 104 at 200 percent. Trim out the copy with the X-acto knife and ruler.

8. Lightly trace the card template onto sheets of card stock with a pencil and score along the fold lines using the bone folder and ruler. Using the ruler, X-acto knife, and cutting mat, cut out the cards along the pencilled lines.

9. Fold the card in half and fold up the CD pocket flap inside the card at the scored fold lines. Crease the folds firmly with the bone folder.

10. Using the hole punch, punch 2 holes for the thread binding on the front of the card, punching through the pocket flap. Position the holes 3/4 inch from each side and 5/8 inch from the card bottom.

11. Measure and cut a 30-inch length of silver thread or string.

12. Starting from the inside of the card, pass the thread through the pocket holes, wrapping the string 3 times back and forth through the holes from the front to the back of the card. Pull the ends taut and tie a knot on the inside of the card.

13. Trim the loose ends with scissors, leaving about 1 inch of thread at each end for decoration.

14. Using the number stamps and embossing stamp pad, print the holiday year numbers on the outside of the card and, while the ink is still wet, sprinkle silver embossing powder over the impression and blow or brush the excess powder away with a soft-bristle paintbrush.

15. Melt the embossing powdered numbers with the embossing heat tool for several seconds by holding and moving the tool above the area so as not to overheat the design. (Helpful hint: We recommend practicing with these tools on scraps of card stock before making your final cards.)

16. Repeat the stamping and embossing process, using the snowflake stamps and clear embossing powder to create the delicate snowflake design on the outside of the card.

17. To decorate the inside of the card, use the glue stick to glue the photocopies to the right inside panel.

18. Use the letter stamps and the gray ink pad to stamp a holiday greeting below the photo and add more embossed snowflakes if desired.

19. Use the letter and snowflake stamps and the gray ink pad to stamp your family name on the CD labels.

20. To finish the card, place a CD label on your photo CD, place the CD in the card pocket, and insert the folded card in a square envelope for mailing.

Pull-out Photo Valentine

Cupid pops up out of this playful photo valentine, perfect for a child to give to his friends or classmates. The child can help make the cards by writing or stamping a Valentine's Day message on the front and inside and stuffing the finished valentines into their envelopes.

You will need:

Black-and-white or color copier

Metal ruler

Proportion wheel

Photograph of child showing mostly head and shoulders

X-acto knife

Self-healing cutting mat

Scissors

Glue stick

Pencil

2 sheets of 8½ by 11-inch card stock in 2 different colors

Bone folder

White craft glue

⅛-inch-diameter hole punch

⅛-inch-wide satin ribbon (allow 6 inches of ribbon per card)

Crayons, markers, or rubber letter stamps and ink pad,
 as desired

5¼ by 7¼-inch envelope for mailing

To make:

1. Using a black-and-white copier, make an enlarged copy of the valentine templates on page 105 at 200 percent.

2. Using the ruler and proportion wheel, measure your photograph from the top of the child's head to the middle of his or her chest and make multiple color or black-and-white photocopies (1 for each valentine) at the percentage of enlargement or reduction at which the child will be approximately the same size as the outline of the child in the enlarged photo template.

3. Cut out the card, heart, and T-stem templates with the X-acto knife, ruler, and cutting mat or scissors.

4. Using the pencil, trace the card and T-stem templates onto one of the sheets of card stock, and the heart template onto the other sheet. Use the X-acto knife, ruler, and cutting mat to cut 2 slits in the front panel of the card and 2 slits in the heart in the exact positions shown on their templates. You can cut right through the templates and then remove them.

5. Using the X-acto knife, ruler, and cutting mat, cut out the card, T-stem, and heart from the card stock.

6. Fold the card in half crosswise and crease the fold with a bone folder.

7. To make the child's photo pull-out piece, use the glue stick to glue the photocopy of the child to a leftover section of one sheet of card stock.

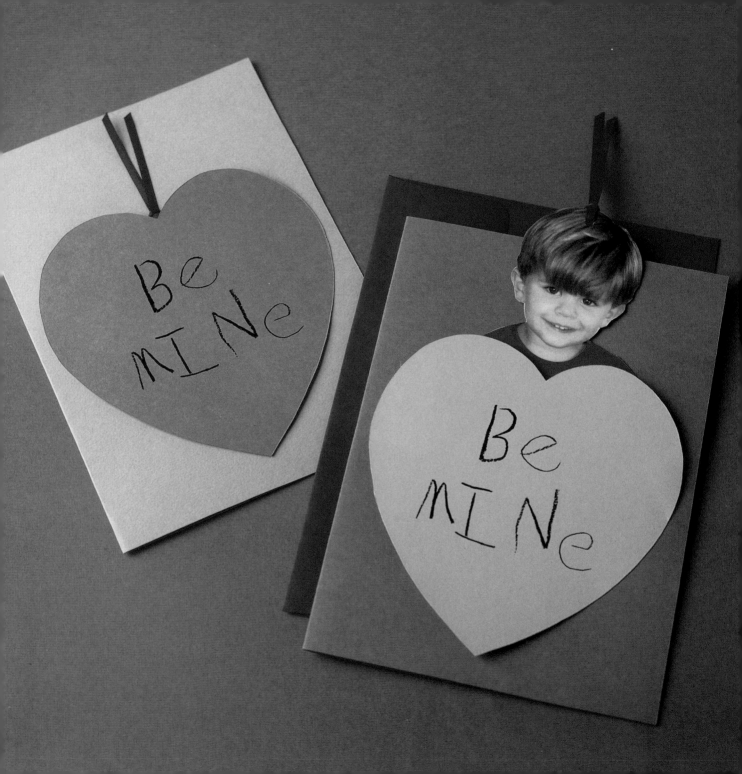

8. Cut out the photocopy of the child with scissors, creating a silhouette.

9. To assemble the card, weave the T-stem through the slits on the front of the card, with the T end at the bottom of the card.

10. Place a tiny drop of craft glue on the top end of the T-stem and glue the stem to the top of the back of the child's head on the pull-out piece, as shown on the template on page 105.

11. Place the heart shape over the child pull-out piece and glue the heart to the card using a drop of craft glue on either side of the heart in the positions shown on the card template.

12. Let the glued areas dry completely, about 10 minutes. When correctly assembled, the child pull-out piece should slide down behind the heart on the T-stem and be completely hidden by the heart.

13. To add the ribbon, pull the child pull-out piece up from behind the heart and using the hole punch, make a hole in the top of the child's head also punching through the attached T-stem.

14. Fold the length of ribbon in half and thread the looped end through the front of the hole and the ends back through the loop to secure the ribbon pull.

15. Slide the child pull-out piece back into the hidden position and trim the ends of the ribbon with scissors so that they do not extend above the top edge of the card when the pull-out piece is hidden behind the heart.

16. To finish, have a child write a Valentine's Day greeting on the front of the heart and sign the inside of the card using crayons, markers, or rubber stamps. Insert the valentine in an envelope to mail.

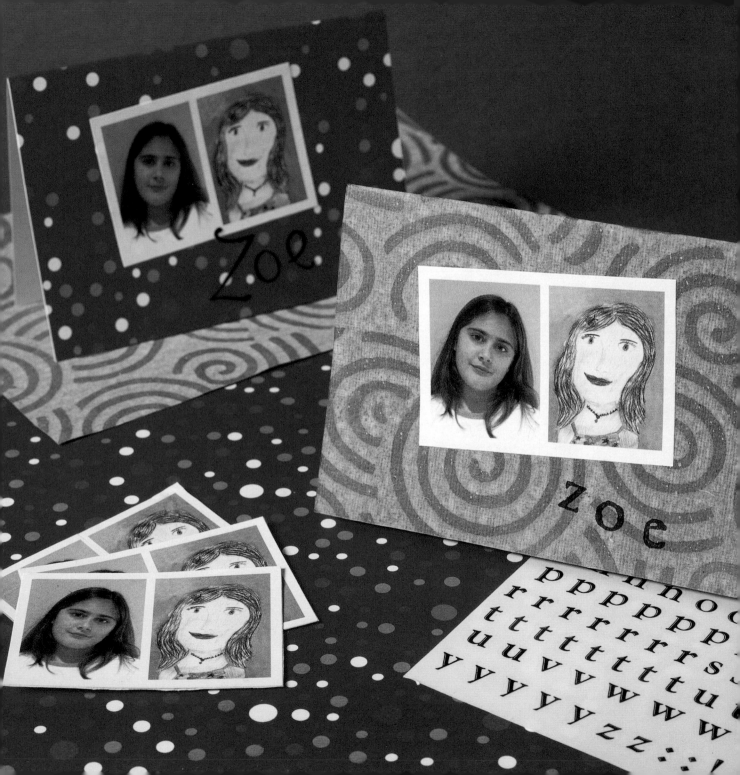

Portrait Note Cards

These fun handmade note cards pair a photographic portrait with a hand-drawn one. Printed on label stock with a color copier, the note cards can be used to personalize a variety of items, such as thank-you notes, notebooks, journals, and file folders.

You will need:

Sheets of 8½ by 11-inch colored or patterned card stock
 (you will get 2 cards from every sheet)

Metal ruler

Pencil

X-acto knife

Self-healing cutting mat

Bone folder

4 by 6-inch vertical photographic portrait (head-and-
 shoulders framing works best)

8½ by 11-inch drawn or painted vertical portrait of the
 same person as the photo

Color copier

1 sheet of 8½ by 11-inch white bond paper

Glue stick

Black-and-white copier

Sheets of 8½ by 11-inch white laser printer labels
 (available at office-supply stores)

Letter stamps and ink pad, or letter stickers

3⅝ by 5⅛-inch envelopes for mailing

To make:

1. With a sheet of card stock in an upright, vertical orientation, use the ruler, pencil, X-acto knife, and cutting mat to measure and trim off 1 inch from the top and 1½ inches from the side of the sheet. Trim the remaining sheet in half crosswise to make 2 cards measuring 5 by 7 inches each.

2. Fold each card in half crosswise and crease the fold firmly with the bone folder. Repeat with additional sheets of card stock to make multiple cards.

3. To make a portrait label template to use on the color copier, use the ruler, X-acto knife, and cutting mat to measure and trim ½ inch off the top or bottom of the portrait photo so that it measures 4 by 5½ inches, then set aside.

4. Place the 8½ by 11-inch portrait artwork on the color copier and adjust the copier settings to make a reduced copy at 50 percent.

5. Use the ruler, X-acto knife, and cutting mat to measure and trim the reduced artwork copy. Trim an additional ¼ inch from either side so that it measures 4 by 5½ inches.

6. Turn the sheet of bond paper horizontally and with the ruler and pencil, measure and draw a light rectangle in the center of the page that is 9 3/16 by 6¼ inches.

7. Place the color copies of the photo and artwork side by side inside the rectangle, leaving ⅜ inch of space between the pictures and all margins.

8. Glue the copies in place with the glue stick.

9. On the outside of each corner of the light rectangle, measure and draw two ¼-inch dark pencil lines perpendicular to each side for trimming guides.

10. Place the finished portait label template on the color copier and make at least 15 copies reduced at 29.5 percent.

11. Using the X-acto knife, ruler, and cutting mat, trim out the copies using the trimming guides. You will have a small white border around and between the portraits.

12. Make a black-and-white copy of the Portrait Note Card template on page 106 at 200 percent on the copy machine.

13. Using the enlarged template, place the 15 color copies of the portraits inside each box of the template and glue them in place with the glue stick.

14. Place the template in the color copier and hand feed sheets of label stock into the machine to make multiple copies.

15. Trim the portrait labels with an X-acto knife and ruler, following the template grid lines as guides.

16. To assemble the cards, peel off the backing from the portrait labels and stick a label on the front of each card.

17. Add a name under the portraits with rubber letter stamps or stickers. Insert into envelopes when ready to mail.

Folding Keepsake Growth Chart

Most of us record the growth of our children on the back of a door or wall, only to leave it behind if we move to another house. You can create a keepsake memento of your child's growth and include photographs for each measuring time by making this folded-paper growth chart. We used a colorful tape measure ribbon to tie the chart together, and it also allows you to determine inch increments at each foot of growth. Use a muted paper color for your chart as shown, or three different colors for the joined sections of the chart band. The photos and nameplate are attached only at the corners, allowing the ribbon to slide freely through the slits in the chart. The chart can be hung on the wall or folded and tied into a book, as desired.

You will need:

24-inch metal ruler

Pencil

X-acto knife

Self-healing cutting mat

1 sheet heavyweight colored paper at least 19½ by 25½ inches in size (available at art and craft supply stores)

Bone folder or burnisher

Bookbinding glue (acid-free craft glue)

3 yards ⅝-inch-wide tape measure ribbon (available at fabric and ribbon supply stores; see Resources)

Double-stick tape

Clear plastic, adhesive-backed picture hanging tab (available at art and frame supply stores)

Rubber number stamps, 1 through 6, and ink pad (optional)

Pen

Acid-free photo adhesive stickers

3½ by 5-inch photographs, with white borders, if desired

Small piece of coordinating colored paper for nameplate

Glue stick

Decorative-edged scissors (optional)

Scissors

To make:

1. Using the ruler, pencil, X-acto knife, and cutting mat, measure and cut the sheet of large colored paper lengthwise into three 6 by 25½-inch strips. Trim 2 of the strips to 24½ inches long, and the remaining strip to 24 inches long.

2. With the ruler and pencil, measure and lightly mark each strip into 6-inch sections. (Each strip will have four 6-inch sections.) Score each section crosswise with the bone folder or burnisher, using the ruler and pencil marks to guide the scoring lines. You will have an extra ½-inch-wide tab on 2 of the strips that will become the glue flaps for joining all 3 strips into one long 6-foot band.

4. Apply a thin coating of bookbinding glue on each ½-inch tab and attach the 3 long strips together, joining the 2 longer strips to the ends of the short strip. Let dry for about 15 minutes.

5. Fold the long band at the score lines into an accordion, creasing the folds firmly with the bone folder or burnisher.

6. Stack the chart in the 6-inch-square folded position and, if necessary, trim the sides flush using a very sharp X-acto knife and the metal ruler.

7. To make the slits in the chart for the ribbon, keep the chart in the folded, stacked position. On the top panel of the chart, using the ruler and pencil, measure and mark the center point on the edge of the folded sides with a small pencil mark. Then measure and draw a pencil line, centered on the mark, that is ¾ inch long and ⅜ inch in from the folded side. Repeat on the other folded side at the center point on the top panel of the chart.

8. Using the X-acto knife, ruler, and cutting mat, make the slits along the ¾-inch-long pencil guidelines, cutting firmly through all thicknesses of the folded, stacked chart.

9. To thread the ribbon through the slits in the chart, unfold the chart. Starting from the underside of one end of the chart, carefully weave the ribbon through the slits. When the ribbon has been woven through all the slits, gently pull it through the length of the chart so that the bottom of the chart falls at a 1-inch mark on the ribbon and leaves at least 12 inches of extra ribbon above and below the chart for tying.

10. Attach the ribbon to the underside of the bottommost panel of the chart with a small piece of double-stick tape placed below the ribbon slit.

11. Attach the clear plastic hanging tab on the underside of the topmost panel of the chart, being sure to position it below the ribbon slit so that the ribbon can slide freely.

12. Starting at the topmost panel of the chart, stamp or write each 1-foot mark in the upper left corner on every other 6-inch panel with a rubber stamp or pen.

13. Place adhesive photo corners on the backs of your photos and mount the photos on the chart panels at the appropriate growth intervals.

14. Record the age, date, and exact growth measurement under each photo with a pen or pencil.

15. To make the nameplate, measure and cut a 2 by 3½-inch rectangle out of another piece of colored paper.

16. To make a border for the nameplate, measure and cut a 2½ by 4-inch rectangle out of a different-colored paper and glue the nameplate to the border with the glue stick. Cut the border with decorative-edged scissors if desired.

17. Write or stamp the child's name on the nameplate and mount it to the bottom panel of the chart with adhesive photo stickers attached to the back corners of the border.

18. Trim the ribbon tails with scissors to finish. If you wish to store the chart in the folded position, fold it into an accordion and tie the ribbon ends in a bow.

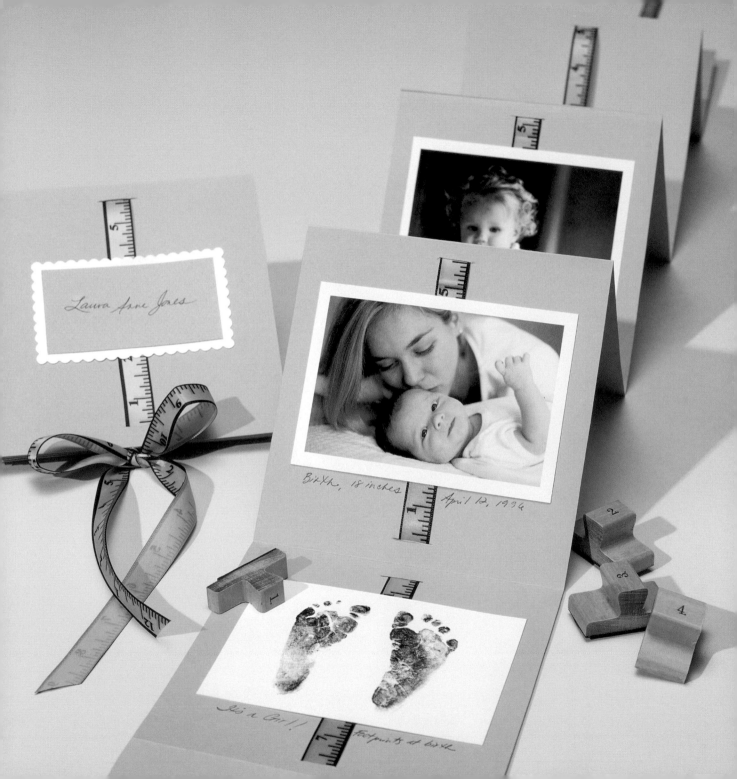

Laura Anne Jones

Birth, 18 inches April 12, 1996

It's a Girl!! Footprints at birth

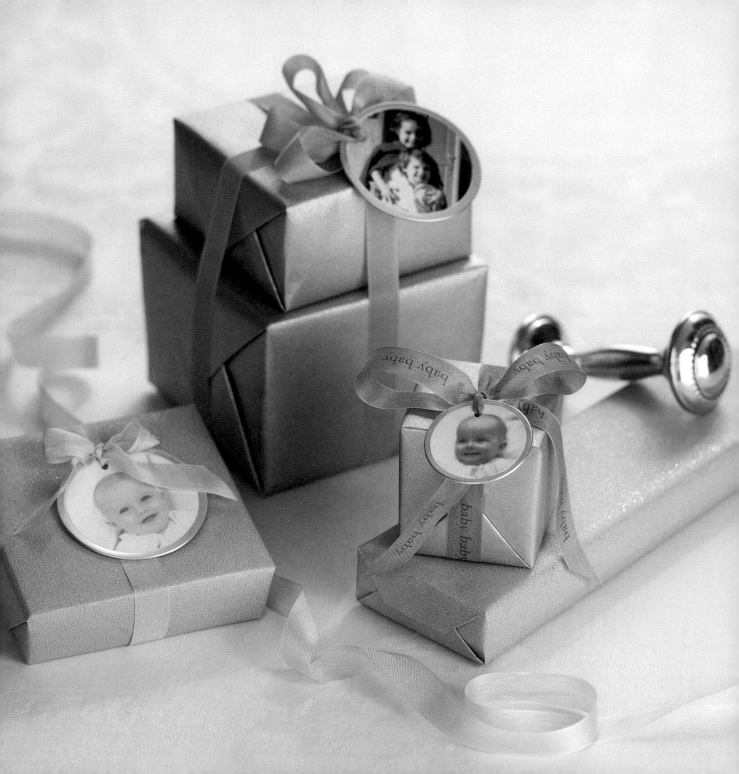

Photo Gift Tags

These gift tags are easy to make and a great way to personalize a gift for any occasion. Use baby photos for baby-shower or newborn gifts, photos of friends or family to adorn their birthday presents, and photos of parents or grandparents to decorate gift tags for Mother's and Father's Day gifts. After applying the photo to one side of the cardboard tag, use the other side to write your gift message.

You will need:

Round metal-rimmed cardboard key tags, 1½-inch and
 2¼-inch sizes (available at office supply stores)

Ruler

Proportion wheel

Color copier, or personal computer, desktop publishing
 software, and color inkjet printer

Pencil

Photo prints

Circle template (available at art supply stores)

Scissors

Glue stick

⅛-inch-diameter hole punch

½-inch-wide ribbon

Pen

To make:

1. Measure the diameter of the inner circle (inside the metal rim) of your key tags with the ruler.

2. Using the proportion wheel and ruler, determine the percentage of enlargement or reduction for your photos (or areas of detail in the photos) so that they will fit the diameter of the tag.

3. Using a color copier, or a personal computer with desktop publishing software and a color inkjet printer, make color copies or prints of your photos at the predetermined sizes.

4. With a circle template and pencil, draw a circular cutting guideline on the color copy with the same diameter as the inside of the tag.

5. Cut out the photo circles with scissors and glue to the tags with a glue stick.

6. Turn the tags over and use the prepunched tag holes in the cardboard as a guide to punch through the photos with the hole punch.

7. After wrapping your gift with paper and ribbon, thread one of the ribbon ends through the tag hole and write your gift message with a pen on the blank side of the tag to finish.

Child's Keepsake Memory Album

Similar to the Vacation Photo Album on page 45, this memory album with a cutout photo window on the cover is created with beautiful handmade papers. A contrasting colored paper is used for the folded paper spine, and card stock is used for the inside pages. You will want to record precious memories of your children with words and photos in this one-of-a-kind photo album.

You will need:

Spray adhesive

2 sheets 8½ by 11-inch handmade paper for the album covers (available at art and scrapbook supply stores)

2 sheets 8½ by 11-inch colored card stock for the inside covers

Metal ruler

Pencil

X-acto knife

Self-healing cutting mat

1 sheet 8½ by 11-inch handmade paper in another color for the album spine

1/16-inch-diameter hole punch

20 sheets 8½ by 11-inch white or ivory card stock for the inside pages

Large trussing needle (available at fabric supply stores)

28-inch-length natural-colored twine

Scissors

3½ by 5-inch photograph of the child

White acid-free paper photo corners

Pen

Rubber letter stamps and ink pad (optional)

1 sheet 8½ by 11-inch vellum

Other photos and ephemera

To make:

1. Apply spray adhesive on one side of each of the 2 sheets of handmade paper and mount them to the 2 sheets of colored card stock.

2. With the mounted sheets turned horizontally and the card stock side facing up, use the ruler and pencil to lightly draw a 2½ by 3-inch window on one of the covers, positioning it equidistant from the top and bottom edges and 3½ inches from the right-hand side.

3. Cut out the window with the X-acto knife, ruler, and cutting mat. This will be the front cover of the album.

4. To make the spine of the album, take the different-colored sheet of 8½ by 11-inch handmade paper and trim 1 inch off the bottom so that the paper measures 8½ by 10 inches.

5. Turn the sheet horizontally and fold the sheet in half crosswise. Open the sheet again and fold the left and right sides in toward the center, then fold again at center, creasing all the folds with your hand. The double-folded spine should measure 2½ by 8½ inches.

6. Stack the front album cover on top of the back cover with the covers oriented horizontally and the handmade paper sides facing out.

7. Place the spine over the left side of the stacked album covers.

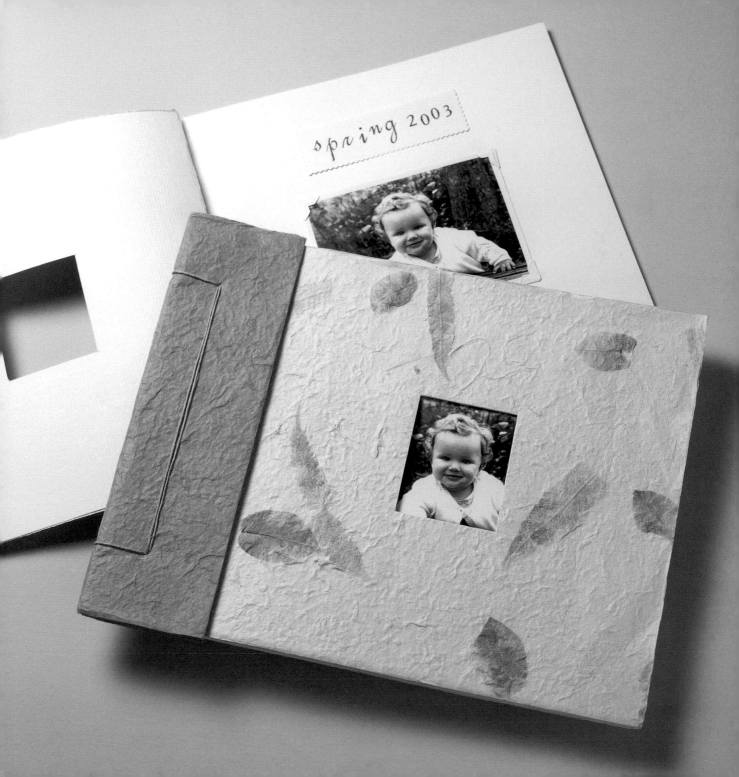

8. Using the ruler and pencil, make 2 pencil dots on the spine for the binding holes, positioning them 1½ inches from the top and bottom edge and 1 inch from the left side of the spine.

9. Using the hole punch, punch holes through the pencil dots, punching through both the spine and covers.

10. Remove the front cover from the spine and use it as a placement template to punch binding holes on the left sides of all 20 sheets of inside pages, oriented horizontally.

11. Stack the front cover on top of the pages and place the stack on top of the back cover, wrapping the front of the spine over the stack and aligning all binding holes.

12. To bind the album, thread the needle with the length of twine. Bring the needle up through the back of the upper binding hole, reserving 6 inches of loose twine on the back of the album. Continue threading the needle down the front of the spine, through the lower binding hole, up the back of the spine, and back through the upper hole again. Thread the needle down through the lower hole again, pulling the twine taut and reserving 6 inches of loose twine on the back of the album at the bottom.

13. Wrap each loose end, at top and bottom, sideways around to the front of the album and thread it back through its hole, pulling it taut. With the album turned on its back, tie each loose end to the perpendicular binding twine close to the binding holes and knot (see photo detail at right).

14. Trim any excess twine close to the knots with scissors.

15. Turn the album over on its front side and open the cover.

16. Mount a 3½ by 5-inch photograph on the first page with photo corners, positioning the photo on the page so that it is framed by the cut-out cover window when the album is closed.

17. Write the title of the album on a small piece of vellum with a pen or the letter stamps and ink pad.

18. Cut out the vellum title with decorative-edged scissors if desired and coat the back with spray adhesive.

19. Mount the title above the photo on the first album page.

20. Fill the other pages with mounted photos, journal notations, or ephemera relating to the theme of your album.

Vacation Photo Album

Create a souvenir of your next family vacation, or an heirloom album of vacations past, using beautiful papers and favorite photos. Start by assembling materials that relate to your vacation, such as maps, rubber stamps, or memorabilia that you may have collected on your trip.

You will need (for a 16-page album, 9$\frac{1}{2}$ by 6$\frac{1}{2}$ inches):

24-inch metal ruler

Pencil

X-acto knife

Self-healing cutting mat

16 by 20-inch piece of acid-free two-ply, 100-percent rag mat board (available at art supply stores)

Small clear plastic triangle

Decorative paper or paper map for outside and inside covers

Decorative-edged scissors

Small foam brush

Bookbinding glue (acid-free craft glue)

Rubber stamps and ink pads

Double-stick tape

$\frac{1}{8}$-inch-diameter hole punch

20 by 30-inch sheet of acid-free, heavyweight drawing or charcoal paper (available at art supply stores)

16-inch length of cotton twine or other thick twine or string

2 sheets 8$\frac{1}{2}$ by 11-inch bond paper

Memorabilia, such as postcards, stamps, tickets, or stickers

White or ivory acid-free paper photo corners

To make the album cover:

1. Using the ruler, pencil, X-acto knife, and cutting mat, measure and cut a 6$\frac{3}{4}$ by 19-inch piece of two-ply rag mat board.

2. Fold it in half crosswise, creasing the fold with your hand.

3. With the cover oriented horizontally, open the front cover. On the backside of the front cover, measure 4$\frac{1}{8}$ inches from the spine fold line and 2$\frac{1}{4}$ inches from the top and bottom and lightly draw a window 2$\frac{1}{4}$ inches square with the pencil and ruler.

4. Cut out the square along the pencil lines, using a very sharp X-acto knife, small plastic triangle, and cutting mat.

5. Close the cover and use the front and back cover panels like a template to lightly trace the cover onto the map or decorative paper with the pencil. (For the album shown here, we cut 2 separate panels out of the map, one for the front cover and one for the back, leaving a 1$\frac{1}{2}$-inch-wide margin on either side of the spine and a $\frac{1}{4}$-inch margin on the outer sides of the mat board cover.) For the front cover panel only, also trace the aperture of the front cover cutout square onto the map or decorative paper, then measure and trace a second square around it that is $\frac{1}{8}$ inch larger on all sides for the border.

6. Using the X-acto knife, ruler, and cutting mat, cut out the map or decorative paper cover panels along the tracing lines. On the map panel for the front cover, cut out the larger square along the tracing lines.

7. On the map panel for the front cover, cut the right-side edge of the map paper with decorative-edged scissors. On the map panel for the back cover, cut the left-side edge with decorative-edged scissors.

Vacation Photo Album (continued)

8. Using the foam brush, coat the back of the map or paper pieces with a light coating of bookbinding glue.

9. Position the front map piece on the outside front cover panel, carefully centering the paper cutout square around the cover cutout square and aligning map edges with the top and bottom cover edges. Press down and gently smooth out any air pockets with your hand. Repeat the steps for the outside back cover with the other piece of map or paper. Let dry.

10. Decorate the front and back cover panels and the uncovered margins next to the spine using rubber stamps or other memorabilia as desired.

11. Select a photo for the front cover cutout square and trim it so that it is $1/4$ inch larger than the cutout square on all sides.

12. Position the photo on the back of the front cover, centered within the cutout square, and secure it to the cover with small pieces of double-stick tape at the corners.

13. To line the inside cover, lay the cover flat and, using a pencil, trace the perimeter of the cover onto another sheet of map or decorative paper.

14. Trim along the pencil lines with the X-acto knife, ruler, and cutting mat, then fold in half crosswise.

15. Apply a light coating of bookbinding glue to the back of the paper and glue it to the inside cover panels, pressing and smoothing out any air pockets as before.

16. When dry, open and lay the cover flat with the outside covers facing out. Punch 2 holes in the center fold line of the spine, equidistant from the top and bottom edges, with a hole punch.

17. To finish, cut the side edges of the paper-covered front and back covers with decorative-edged scissors, if desired.

To make the album pages:

18. Using the metal ruler, pencil, X-acto knife, and cutting mat, measure and cut the heavyweight drawing paper into 4 strips, $6\frac{3}{4}$ by $18\frac{1}{2}$ inches long. Fold each strip in half crosswise, creasing the folds with your fingers.

19. Open the strips and lay them flat again. Punch 2 holes in the center fold line of the spine of each strip, in the same positions as on the cover, with the hole punch.

20. Stack the flat strips on top of each other so that all spines and spine holes are aligned. Lay the flattened cover, with the inside cover facing up, under the stack of pages and align the spine and the spine holes with those of the pages.

21. Starting from the top of the stack of pages, thread the twine through the top and bottom holes of the pages and then the cover, pushing the twine through the holes with the tip of a pencil if necessary. The two ends of twine should be dangling from the outside holes of the cover spine when properly threaded. Pull the ends taut against the spine and tie in a knot and then in a bow. Knot the tips of the ends to finish.

22. Fold the album closed and cut the right sides of the album pages with decorative-edged scissors if desired.

23. Place the album between 2 sheets of clean bond paper and top with several heavy books for 24 hours to make the folded album lie flat.

24. To finish the album and make the cover and pages perfectly flush, trim $1/8$ inch off the top and bottom edges of the closed album, making a clean cut through the cover and pages using the ruler and a very sharp X-acto knife.

25. Decorate the pages with rubber stamps, memorabilia, and vacation photos mounted with paper photo corners.

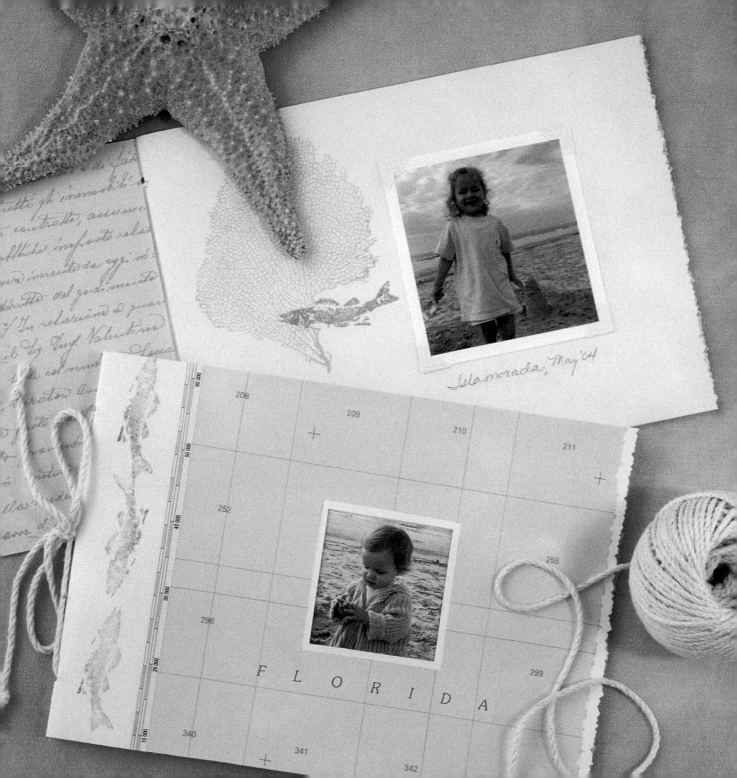

Islamorada, May '04

FLORIDA

Photo Bookplates

These photographic bookplates are a great way to personalize your own or a child's library, or make a terrific gift to send with a book to a friend.

You will need:

Metal ruler

Pencil

X-acto knife

Self-healing cutting mat

4 by 6-inch vertical portrait photo

Color copier

8½ by 11-inch sheets of white bond paper

Small rubber letter stamps and ink pad

Proportion wheel

Black-and-white copy machine

Glue stick

Decorative-edged scissors (optional)

8½ by 11-inch full sheets of white laser printer labels
 (available at office supply stores)

To make:

1. Using the ruler, pencil, X-acto knife, and cutting mat, measure, mark, and trim 1¼ inches from the top or bottom of the photograph so that it measures 4 by 4¾ inches.

2. Place the trimmed photograph on a color copier and make 8 color copies reduced at 35 percent.

3. Trim the photocopies with the X-acto knife and ruler.

4. On a sheet of bond paper, use the letter stamps and ink pad to print out the text line: "From the library of."

5. Use the letter stamps or the actual signature of the book owner to create the person's name.

6. Using the ruler and proportion wheel, determine the size of reduction for the text line and name so that they will each be approximately 1⅞ inches long.

7. Place the bond paper on a black-and-white copy machine and make 8 reduced copies at the predetermined size.

8. Trim out the text and name strips with the X-acto knife and ruler.

9. Make a multiple-bookplate template by creating a pencil line grid on another sheet of bond paper. Turn the sheet horizontally and draw a 10 by 7-inch rectangle on the sheet, allowing a ¾-inch margin at top and bottom and a ½-inch margin on either side. Divide the rectangle into 8 equal parts that each measure 2½ by 3½ inches.

10. Using the glue stick, glue a portrait photocopy, line of text, and name strip inside each small rectangle. Stack the photo, text, and name as shown in the photograph.

11. Place the bookplate template on the color copier and hand feed the label stock into the machine to make multiple copies as desired.

12. Trim the bookplates with the X-acto knife or decorative-edged scissors, using the penciled grid lines as a guide.

13. Peel off the label backing to affix labels to the inside of a book when ready to use.

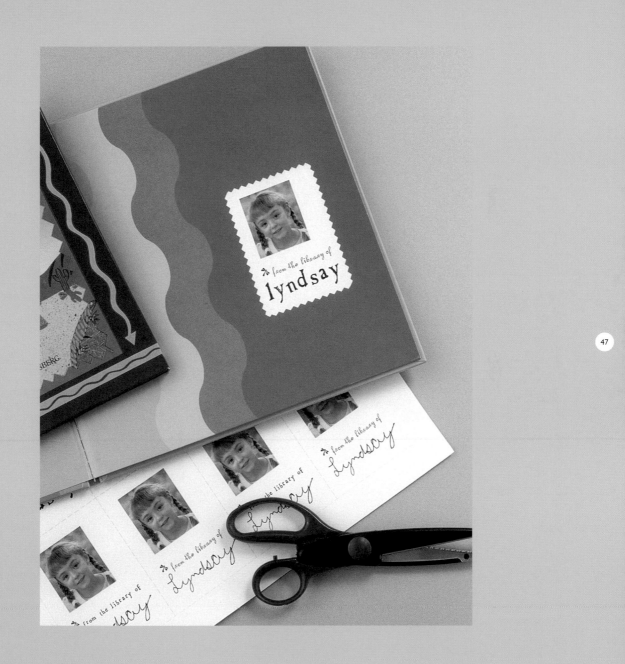

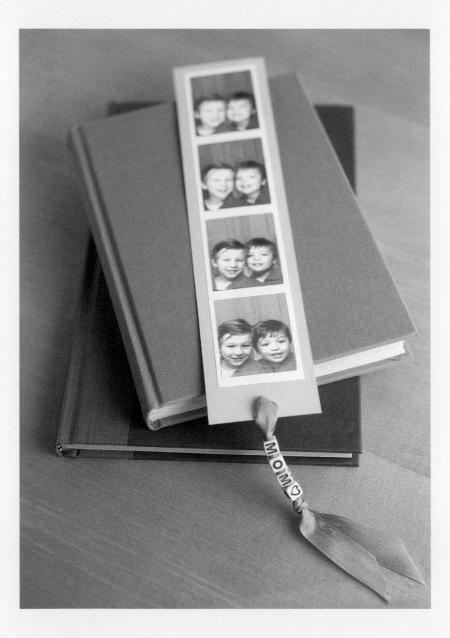

Photo Booth Bookmarks

Photo booths are found in malls and amusement centers nationwide. Create a fun strip of photos to use for personalized bookmarks for a family member or to give as a gift to a loved one to remember you by.

You will need:

Strip of 4 photos from a photo booth

Color or black-and-white copy machine

Metal ruler

Pencil

X-acto knife

Self-healing cutting mat

Sheet of 8½ by 11-inch colored card stock
 (this will make 4 bookmarks)

Glue stick

⅛-inch-diameter hole punch

⅝-inch-wide rayon seam-binding ribbon, 12 inches
 per bookmark (available at ribbon and fabric stores)

Alphabet beads (available at bead and craft stores)

Scissors

To make:

1. Make 4 color or black-and-white copies of the photo strip as desired.

2. Using the ruler and pencil, draw a ⅛-inch border around each strip.

3. Using the X-acto knife, ruler, and cutting mat, trim the photo-strip copies along the pencil lines.

4. Measure, mark, and trim the sheet of card stock into four 2 by 9-inch strips.

5. Apply glue to the back of the photo-strip copies with a glue stick and center a photo strip on each card strip, leaving slightly more room at the bottom end of the card than the top, as shown in the photograph.

6. Using the hole punch, punch a hole in the center of the bottom of each card strip, placing the hole ¼ inch from the bottom edge.

7. Thread a 12-inch length of ribbon through the hole. Thread the alphabet beads onto the ribbon ends spelling out a person's name or message.

8. Knot the ribbon ends together below the beads and trim the ends neatly with scissors to finish.

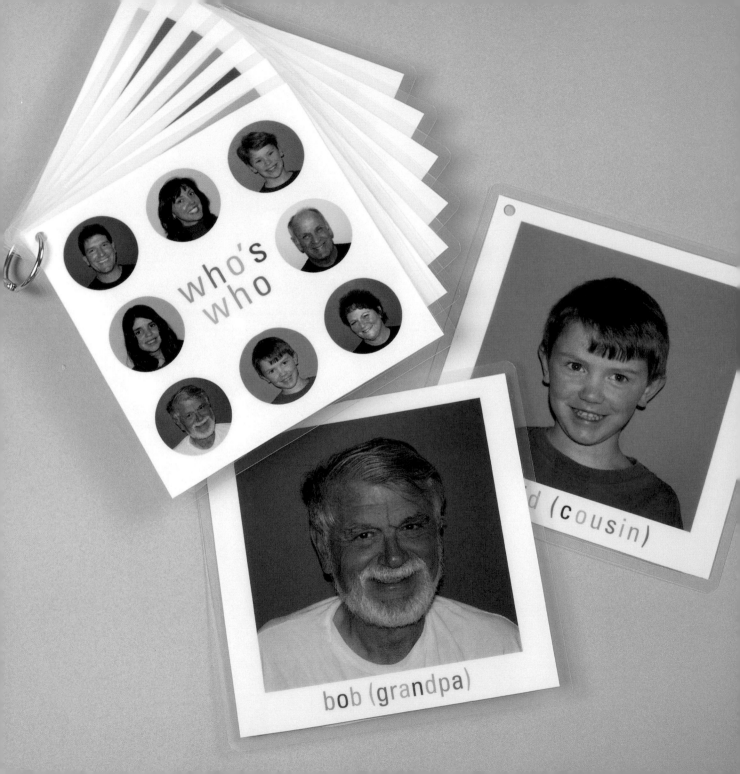

who's who

bob (grandpa)

d (cousin)

Family Who's Who Book

It often takes young children a long time to understand their family relationships outside their immediate family. You can help a child sort out all his relations with these large photo "flash cards" created on either a color copier or a personal computer and inkjet printer. Add each person's name and his or her relationship to the receiver, laminate the cards at your local copy shop, and bind them together into a book with a large metal binder ring.

You will need (if making on a color copier):

Sheets of 8½ by 11-inch white bond paper

Ruler

Pencil

Proportion wheel

Color photo portrait prints of each family member

X-acto knife

Self-healing cutting mat

Double-stick tape

Colored letter stickers

1½-inch-diameter circle punch

You will need (if making with a personal computer):

Desktop publishing software

Digital portrait scans of each family member

8½ by 11-inch inkjet paper

Color inkjet printer

X-acto knife

Ruler

Self-healing cutting mat

To finish (whether making with a copier or computer):

Laminating machine or laminating services at a copy shop

Scissors

¼-inch-diameter hole punch

Metal binder ring (available at office supply stores)

To make using a color copier:

1. Make page templates by drawing 6-inch squares on bond paper using the ruler and pencil. You will need 1 template for each family portrait plus 1 more for the cover page.

2. Inside each square, lightly draw a 4⅞-inch square, positioning it ⅜ inch from the top edge, ¾ inch from the bottom, and ½ inch from either side. This will be your positioning guide for your color portraits.

3. Using the ruler and proportion wheel, determine the percentage of enlargement or reduction necessary to size each portrait so that it will fit inside the 4⅞-inch square.

4. Make a color copy of each portrait at the predetermined size and trim it into a square using the ruler, X-acto knife, and cutting mat.

5. Place the portraits on the bond paper templates aligning the portraits within the lightly drawn inner squares and adhering them with pieces of double-stick tape.

6. Use the letter stickers to spell out the person's name and his or her relationship to the receiver of the book. Center the stickers under the portrait inside the bottom margin of the 6-inch squares.

7. Make a final color copy of each template page at 100-percent scale.

8. Using the ruler, X-acto knife, and cutting mat, trim the copies into the 6-inch squares using the pencil lines as guides.

9. To make the cover, use the ruler and proportion wheel to determine the percentage of enlargement or reduction necessary to fit each portrait inside a 1½-inch-diameter circle.

10. Make a color copy of each portrait at the predetermined sizes and punch out portrait circles using the 1½-inch circle punch.

11. Create a grid of 8 portrait circles on the cover template allowing a ⅜-inch margin on all sides and between each circle. Leave an empty space in the center for the title.

12. Using small pieces of double-stick tape, attach the portrait circles to the cover template.

13. Spell out the title with letter stickers (as shown in the photograph) and make a final color copy of the cover template at 100-percent scale.

14. Using the ruler, X-acto knife, and cutting mat, trim the cover into a 6-inch square using the pencil lines as guides.

To finish:

15. Have your cover and pages laminated and trimmed at a copy shop leaving a ¼-inch border of laminate on all sides.

16. Round the corners with scissors.

17. Punch holes in the same position of the upper left corners of all pages using the ¼-inch hole punch.

18. Place the cover on top of the inside pages and bind together with the metal binder ring.

To make using a personal computer:

1. Create a multi-page document using desktop publishing software, making the pages 6 inches square. Allow 1 page for the cover and 1 for each family portrait to be included.

Import a digital photo scan onto each page and crop the portraits to fit a 4⅞-inch square, positioning it ⅜ inch from the top edge, ¾ inch from the bottom, and ½ inch from either side.

2. Type each family member's name centered under his or her portrait in the bottom margin. (We used multicolored 36-point Univers 57 Condensed type for the names.)

3. To make the cover, import 8 of the portrait scans onto the cover page of your document and size and crop them into 1½-inch squares.

4. Make 1½-inch circle masks around each square and position the portrait circles in a grid, allowing a ⅜-inch margin on all sides and between each circle. In the center of the cover where there is no portrait circle, type the title of your book. (We used multicolored 60-point Univers 57 Condensed type for the title.)

To finish:

5. Print out the cover and inside pages on inkjet paper using the color inkjet printer, being sure to select crop marks in your print menu before printing.

6. Trim out all the pages with the X-acto knife, ruler, and cutting mat, using the crop mark guides. Follow steps 15 through 18 on the previous page for laminating and binding your pages.

Note: To create the simple, colorful portraits for this project, we photographed each family member in front of a different-colored background. We used 19½ by 25½-inch sheets of multicolored Canson paper (available at art and craft supply stores) for the background colors, and photographed just the head and shoulders of each person in a horizontal aperture format.

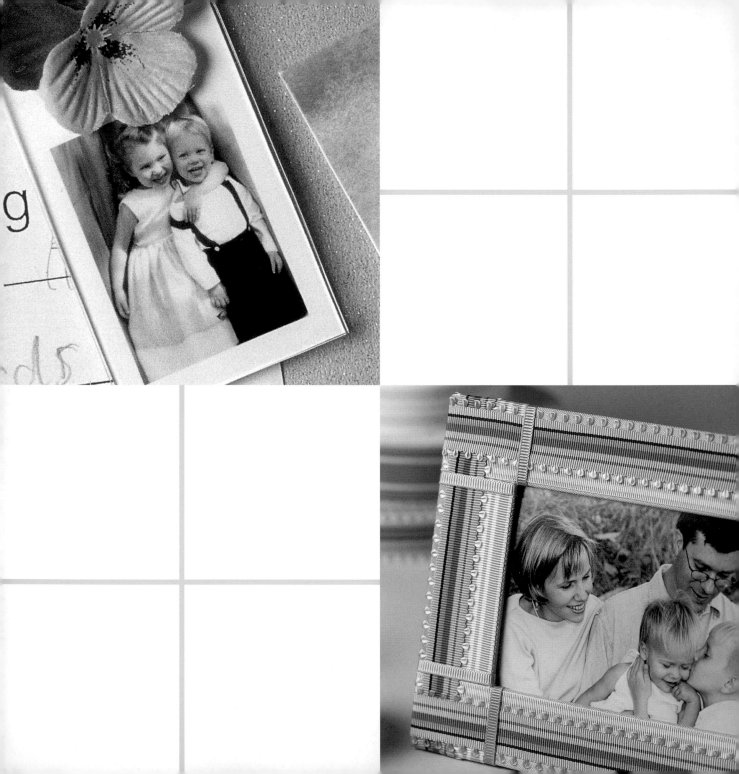

Frameworks

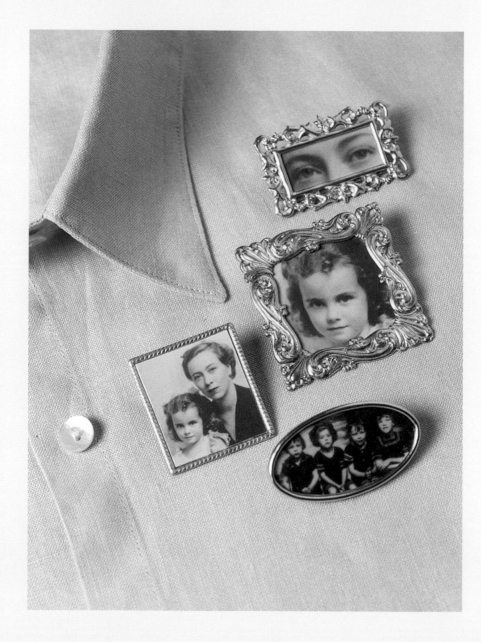

Photo Frame Pins

These one-of-a-kind pins were created using decorative miniature metal frames. Assemble some of your favorite old family photos and experiment with cropping the photos in ways that best suit the shapes of your frames.

You will need:

Old photographs or digital scans of old photographs

Miniature metal frames (available at craft and scrapbook supply stores)

Ruler

Proportion wheel

Color copier or personal computer, desktop publishing software, color inkjet printer

Glossy inkjet paper (if using color inkjet printer)

Plastic cup

Diamond Glaze brand water-based dimensional adhesive (available at craft and scrapbook supply stores)

Small paintbrush or foam brush

X-acto knife

Self-healing cutting mat

All-purpose craft glue

.005-gauge brass sheeting for frame backing (available at hobby shops; optional)

Multipurpose cement

1-inch gold bar pins (available at craft supply stores)

To make:

1. Decide which photo to place in each miniature frame.

2. Measure the aperture of each frame with a ruler. Using a proportion wheel, determine the percentage of reduction or enlargement needed for each photo to fit its frame.

3. If using a color copier, make copies of the photos at the predetermined sizes.

4. If using a personal computer, create a page document for your photos using desktop publishing software, and import your digital scans to the document. Size and crop your scans to the predetermined sizes and make a print of the photos on a color inkjet printer using glossy inkjet paper.

5. In a plastic cup, mix 2 parts dimensional adhesive to 1 part water. Using the small paintbrush, apply a light protective coating of the adhesive mixture to the front of the photocopies or inkjet prints and let dry completely, about 30 minutes.

6. Trim the photos to the predetermined dimensions of the frame apertures, using the X-acto knife, ruler, and cutting mat.

7. If the frame has a metal backing, glue the photo to the inside of the frame back with craft glue and let dry.

8. If the frame has no backing, use the ruler and X-acto knife to measure and cut a frame back (the size of the frame aperture plus $1/16$ inch larger on all sides) from the brass sheeting.

9. Glue the photo to the center of the backing with craft glue and let dry. Glue the brass backing to the frame by applying a thin line of cement around the edges of the backing and pressing the frame and backing together firmly. Let dry.

10. Glue a bar pin to the back center of each finished frame with cement and let dry completely, about 30 minutes.

Decorative Photo Magnets

Decorate your refrigerator or bulletin board with memorable photos of family and friends tucked inside colorful Lucite photo magnets. Adorned with buttons and small silk flowers, they will add a splash of color to your kitchen or office.

You will need:

Various sizes of Lucite frame magnets (available at office supply and photo-processing stores)

Stems of small silk flowers (available at craft supply stores)

Scissors

Several dozen colored buttons in varying sizes (we used 5/16-inch shirt buttons for the small frames and 1/2- to 3/4-inch buttons for the larger frames)

Multipurpose cement

Photographs

X-acto knife

Ruler

Self-healing cutting mat

White card stock (optional)

Glue stick (optional)

Decorative-edged scissors (optional)

Proportion wheel (optional)

Sheet of white bond paper (optional)

Color copier (optional)

To make:

1. Remove the paper inserts from the magnet frames and save to use as cropping and cutting guides for your photos. Before adding decorations, make sure the frame opening is oriented at the bottom for vertical photos.

2. Cut the flower heads from the silk flower stems with scissors as close to the head as possible.

3. Arrange the flowers and buttons around the edges of the frames until you've created a design you like.

4. Using the multipurpose cement, glue them to the Lucite frames and let dry, about 30 minutes.

5. While the frames are drying, use the paper inserts from the frames as a template to crop your photos to fit the frames. Once you've decided on a crop, use the X-acto knife, ruler, and cutting mat to trim the photos. If you want a white border around the photos, crop and trim the photos at least 1/4-inch smaller than the template, then cut a piece of white card stock to the same size as the frame template.

6. Using a glue stick, mount the photos in the center of the card stock. Cut the edges of the white card with decorative-edged scissors, if desired, and slide the photos into the magnet frames to finish.

Note: If you need to resize a photo to fit a frame, use the ruler and a proportion wheel to determine the size of reduction or enlargement necessary, remembering to allow additional space for a white border, if desired. Use the ruler and X-acto knife to crop and trim the photo proportionate to the size of the frame. Mount the photo on a piece of bond paper with a glue stick, and make a photocopy of your photo at the predetermined size on the color copier. Trim and insert the photo as described in steps 5 and 6.

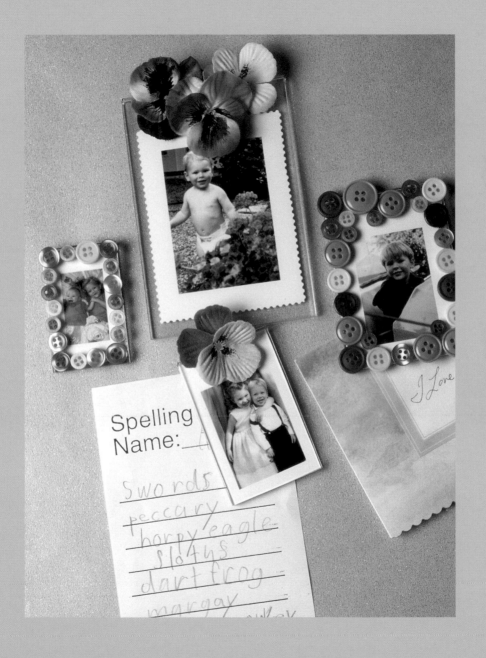

Ribbon-Covered Frames

Use a variety of coordinating ribbons to create a one-of-a-kind handmade photo frame. Cardboard frame kits are available at craft supply stores, but we've also provided a template on page 107 from which to create your own frame using light- and heavyweight chipboard. Choose ribbon colors to complement a favorite photo or the décor of the room in which the frame will be placed.

You will need:

5 by 7-inch cardboard easel-back photo frame kit
　　(see Resources), or one 8 by 16-inch piece of six-ply
　　acid-free chipboard and one 5 by 7-inch piece of single-ply
　　acid-free chipboard (available at art supply stores)

Black-and-white copier (optional)

X-acto knife

Metal ruler

Self-healing cutting mat

Pencil

12-inch-square piece of colored or patterned paper
　　(available at art and scrapbook supply stores)

Bookbinding glue

4 by 6-inch photograph

2 sheets 6 by 8-inch double-sided adhesive tape

Scissors

1 yard $1/2$-inch-wide rayon seam-binding ribbon in a
　　coordinating color to line inner frame

1 yard each of several different-colored ribbons in widths
　　varying from $1/8$ to $5/8$ inch

$5/8$ by $1 3/4$-inch metal hinge (available at hardware stores)

Multipurpose cement

To make:

1. If you are using a photo frame kit, skip to step 7. If you are not using a cardboard photo frame kit, make a black-and-white copy of the template on page 107 enlarged at 200 percent.

2. Cut out the template pieces using the X-acto knife, ruler, and cutting mat.

3. Use template A, the pencil, X-acto knife, ruler, and cutting mat to trace and cut 2 pieces of six-ply chipboard into $5 1/8$ by $7 1/8$-inch rectangles for the front and back frame panels. Using the inner-window guidelines on template A, cut out a picture window in one of the rectangles for the frame front panel.

4. Use template B to trace and cut a 5 by 7-inch rectangle out of the single-ply chipboard for the photo pocket. Using the inner-window guidelines on template B, cut out the picture window.

5. Using template C, cut the easel leg from the remaining piece of six-ply chipboard.

6. To cover the frame back and easel leg with colored paper, lay the cardboard pieces on the back of the colored paper and trace the frame and leg outlines onto the paper with the pencil. You will need to trace the easel leg twice in order to cover both sides. Leave enough room to add an additional

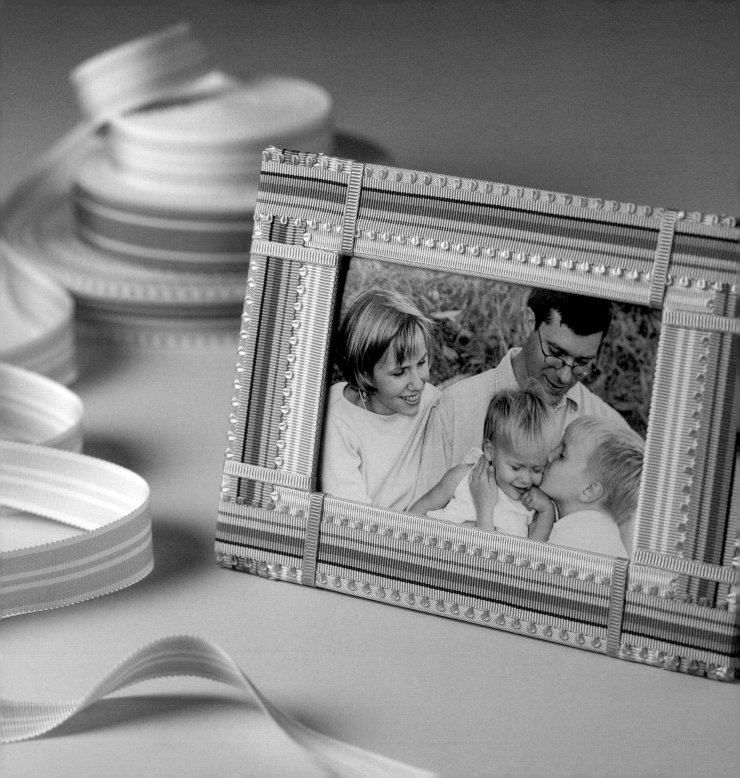

½ inch to each side of the frame back and one of the easel legs as wraparound allowance.

7. Using the X-acto knife, ruler, and cutting mat, cut out the frame back and two easel legs. On the frame back and easel leg with the additional ½ inch, make 45-degree diagonal cuts from each outer to each inner corner so the wraparound allowance folds easily over each side.

8. Coat one side of the cardboard frame back and the cardboard easel leg with bookbinding glue and mount them to the paper frame back and easel leg (with flaps). Wrap the flaps over the cardboard edges, applying more glue to the underside of the flaps to help them adhere to the cardboard.

9. Mount the second paper easel leg (without flaps) to the wrapped easel leg with more glue.

10. To create the photo pocket on the frame back, apply a thin line of glue around 3 sides of the piece of precut single-ply chipboard close to the edges leaving one of the short sides without glue for the pocket opening.

11. Mount the pocket to the side of the frame back with the flaps showing and let dry. Insert the photo into the pocket to make sure it can slide freely in and out of pocket, then remove it.

12. To wrap the frame front with ribbon, first cover one side of the frame front panel with a sheet of the double-stick tape, making ½-inch flaps to fold over the sides and inner window in the same way that you created flaps for the frame back (see step 8).

13. Using scissors, cut 4 strips of the seam-binding ribbon to the length of each side of the inner frame window.

14. Wrap the inner window by folding the strips in half lengthwise, and sticking the ribbon to the double-stick tape on both the front and back of the frame as you work your way around the aperture.

15. Using the different-colored ribbons, lay pieces of ribbon on top of the tape-lined frame in a decorative pattern as desired. Be sure to leave at least ½ inch of extra ribbon on each end of the lengths of ribbon to wrap around the sides and window of the frame. You can weave the ribbons together in a decorative pattern and overlap them to create a layered effect as well.

16. When the frame is completely covered with ribbon, cut ½-inch-wide strips from the second sheet of double-stick tape and apply them to the back of the frame on top of the folded-over ribbon ends along all 4 sides. Mount the frame front to the photo pocket side of the frame back.

17. To attach the easel leg to the back of the frame, position the leg so that the corners of the pointed end of the easel leg are flush to the bottom left corner of the frame back. Take the metal hinge and bring the sides together so that the countersunk screw holes on the sides are facing each other. Lift the easel leg and insert the metal hinge between the leg and the frame back in the position shown in template C.

18. Using multipurpose cement, glue the sides of the hinge to the easel leg and frame back and let dry completely.

19. Insert the photo into the photo pocket opening on the side of the frame to finish.

Fabric-Covered Frames

The kraft-colored oil-board stencils used in this project are normally used as sign-painting stencils and can be found at many craft and art supply stores. Here, we used them as a design element, along with a photo, to create a series of fabric-covered frames that use the stencil cards to spell out a child's name. By mounting the photo to its frame with photo corners, the photo can be easily changed whenever you desire.

You will need:

X-acto knife

Metal ruler

Self-healing cutting mat

4-inch-high oil-board letter stencil set (available at art and drafting supply stores; you may need more than one stencil set if the child's name has several duplicate consonants in it)

Multiple 7 by 9-inch swatches of cotton fabric, one for each canvas frame

Multiple 5 by 7 by ½-inch canvas-covered frames, one for each letter in the child's name plus one more for the photograph (available at art supply stores)

Small foam brush

Mod Podge découpage water-based sealer, matte finish

3½ by 5-inch photograph

Kraft-colored paper photo corners

Framing putty (tacky putty used to mount lightweight objects and frames to walls, available at frame stores; optional)

To make:

1. Using the X-acto knife, ruler, and cutting mat, trim the letters you'll need to spell out the child's name from the stencil set and put aside.

2. Place the fabric swatches, face down, and the canvas frames, face up, on a clean work surface.

3. Using the foam brush, apply an even coating of Mod Podge sealer to the top surface of the swatches and to the tops and sides of the canvas frames.

4. Immediately turn the frames over and place each one face down on top of a fabric swatch, centering it on the swatch.

5. Wrap the fabric over the sides of the frame and onto the back of the canvas, folding the corners diagonally over themselves the way you would wrap a present. You will need to apply more sealer inside the corner folds to make them adhere to each other, and more sealer on the edges of the fabric to adhere it to the back of the frame.

6. Turn the frames face up and use your hands to smooth out any air pockets that may have formed.

7. Apply another coat of sealer to the front and sides of the fabric-covered frames, allowing the sealer to dry for 15 to 20 minutes.

8. Coat the backs of the letter stencils with more sealer and place each letter on a fabric frame, centering the letter on the frame. Apply a final coat of sealer over the stencil and fabric frame and let it dry completely. You should have one extra frame without a letter stencil on it, to be used for the photograph.

9. To add the photograph to the remaining fabric frame, center the photo on the front of the frame.

10. Moisten the backs of 4 paper photo corners, slide them onto the corners of the photo, and press the corners onto the frame to adhere them in position.

11. To display the frames, hang them vertically on the wall with framing putty, or set them horizontally in a row on a shelf, in letter order, inserting the photo frame in between 2 letters or at the end of the name.

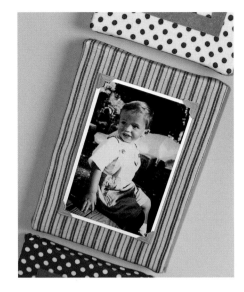

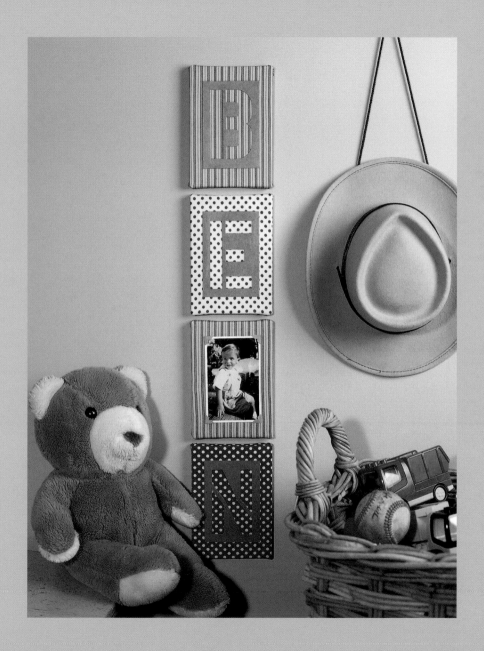

Découpaged Paper-Covered Frames

Photos and beautifully textured Japanese rice paper are the complementary design elements of these understated découpaged paper-covered frames. Here, we chose a white patterned paper to go with the wedding photo because it echoed the bride's lacy, translucent veil.

You will need:

Sheet of 8½ by 11-inch white bond paper

Metal ruler

Pencil

X-acto knife

Self-healing cutting mat

3½ by 5-inch photograph

Drafting tape

Color copier

12-inch-square sheet of Japanese rice paper

8 by 8 by 1-inch canvas-covered frame (available at art supply stores)

Small foam brush

Mod Podge découpage water-based sealer, matte finish

Picture-frame hanging bracket (optional)

To make:

1. On the sheet of bond paper, use the ruler and pencil to draw a 3-inch-square window in the center of the page.

2. Cut out the window with the X-acto knife, ruler, and cutting mat and place the window over the photograph, cropping as desired.

3. Attach the photo to the back of the paper with tape.

4. Place the cropped photo on a color copier and make a copy at 100 percent.

5. Using the ruler and pencil, measure and draw a ¼-inch-wide border around the photo. Cut out the photo along the penciled lines using the X-acto knife, ruler, and cutting mat.

6. Lay the Japanese rice paper, face down, and the canvas frame, face up, on a smooth, clean work surface.

7. Using the foam brush, apply an even coating of Mod Podge sealer to the top surface of the paper and to the top and sides of the frame. Immediately turn the frame over and place it face down on top of the paper, centering it on the sheet.

8. Wrap the paper around the sides of the frame and onto the back of the frame, folding the corners diagonally over themselves as you would fold a present. You will need to apply more sealer inside the corner folds to make them adhere to each other, and more sealer on the edges of the paper so that they will adhere to the back of the frame. Turn the frame face up and use your hands to smooth out any air.

9. Apply 2 more coats of sealer to the front and sides of the paper-covered frame, allowing the sealer to dry for 15 to 20 minutes between coats.

10. To apply the photocopy, apply sealer to the back of the copy and center the photo on the front of the frame. Apply one final coating of sealer over the photocopy and frame and allow it to dry for 24 hours.

11. Display the finished frame on a bookshelf or hang it on the wall, if desired, by attaching a picture-frame hanging bracket to the back of the frame according to the manufacturer's instructions.

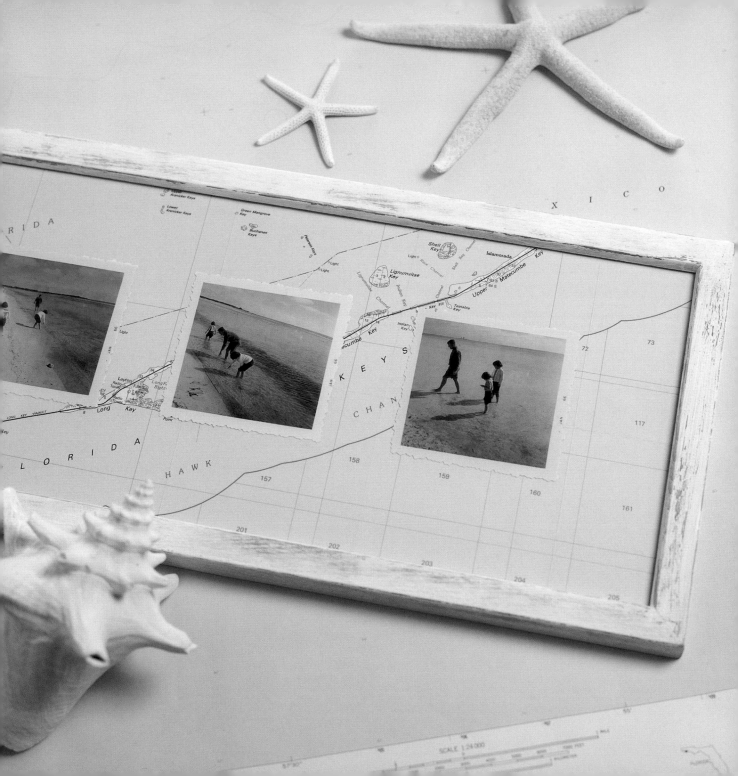

Map Mats

Create a framed memento of a family vacation by mounting your favorite getaway photos on top of a map of your holiday destination. Interesting maps can be found in museums, souvenir stores, books, and by mail order or over the Internet. Here, we chose a U.S. Geographic Survey topographic map because the colors complemented the colors of the sixties-era family vacation photos we selected.

You will need:

Map or color copy of map artwork

Photographs

Color inkjet printer (optional)

Decorative-edged scissors (optional)

Ruler

Pencil

Acid-free photo adhesive stickers

Picture frame (optional)

Acid-free white mat board for frame backing (optional)

X-acto knife

Self-healing cutting mat

Photo spray adhesive (optional)

To make:

1. Find a map or make an enlarged color copy of a map from a book or vacation brochure of your vacation destination.

2. Select photos that will complement your map artwork.

3. Use your original photos, or make high-quality copies of the photos on a color inkjet printer or at your local film and photo-processing store.

4. Trim the photo or photocopy edges with decorative-edged scissors.

5. Arrange the photos on the map, placing them near or around the place you visited. Align the tops of the photos and space them evenly using the ruler, then mark the position of the photo corners with a light pencil dot.

6. Place adhesive stickers on the back corners of your photos and reposition them on the map at the pencil markings, pressing gently to adhere the photos to the map.

7. Frame the piece yourself using a ready-made frame, or take your map with mounted photos to a local framer to be framed. If framing yourself, decide on the final dimensions of your framed piece before trimming the map. Be sure to choose a finished size that corresponds to ready-made frame lengths. Trim the map and acid-free mat board backing to the same size as your finished frame, using the ruler, X-acto knife, and cutting mat.

8. Spray the back of the map with spray adhesive and mount it to the mat board, gently smoothing out all the air pockets.

9. Insert the mounted map into the frame and secure in place according to the instructions accompanying your frame.

Hand-Painted Photo Portraits

Inspired by the work of Pop artist Andy Warhol, these hand-painted photo portraits are a great project for the whole family. High-contrast portraits are printed on watercolor paper and hand painted by each family member to be assembled into a one-of-a-kind art portrait for your home. You can frame 4 different-colored portraits of a single person together as shown, or frame single portraits of each family member together in a grid.

You will need:

Digital photo scan or photo portrait print (front-facing head-and-shoulder portraits on white or light backgrounds work best)

Personal computer, black-and-white laser printer, and Adobe Photoshop software, or a black-and-white copy machine

Sheets of 8½ by 11-inch bond paper

Metal ruler

Pencil

X-acto knife

Self-healing cutting mat

9 by 12-inch pad of lightweight watercolor paper (available at art and office supply stores)

Children's boxed watercolor set with paintbrush

16-inch-square piece of four-ply acid-free mat board

Acid-free photo adhesive stickers

16-inch-square frame

To make using a personal computer:

1. Scan the photograph, if necessary.

2. Using Adobe Photoshop software, convert the scan to a "grayscale" image and save this file in case you need to start over while creating special high-contrast photo effects.

3. Adjust a copy of the grayscale image so that it is bright and high in contrast.

4. To create a grainy posterized effect, select the "Cutout" feature from the "Artistic" menu under your "Filter" menu options. Experiment with the cutout options (number of levels, edge simplicity, and edge fidelity) until you've achieved the effect you want, then save this file with a new name.

5. Enlarge or reduce the image so that it is approximately 7 inches square and will center comfortably on an 8½ by 11-inch sheet of paper.

6. Print out a test print on bond paper on your laser printer to make sure the photo effects and sizing are correct. You will eventually trim the finished prints into 7-inch squares.

7. Using the ruler, pencil, X-acto knife, and cutting mat, measure and cut sheets of the watercolor paper to 8½ by 11 inches, allowing at least one sheet for each portrait.

8. Hand feed the paper through the laser printer to make 4 prints of the portrait plus a couple extra to experiment with when painting.

9. Using the pencil, ruler, X-acto knife, and cutting mat, measure and trim the prints into 7-inch squares so that each portrait is centered in the same position on the page.

10. Paint the portraits with watercolor paints, varying the face, hair, background, and clothing colors in each portrait, and allow the portraits to dry completely.

11. Position 4 portraits butted together into one large 14-inch square in the center of a 16-inch-square mat board.

12. Mark the position of each corner of the 4 portraits with a light pencil mark.

13. Place acid-free adhesive stickers on the back corners of each portrait, replace them into the grid by aligning them at the pencil marks, and press gently to adhere the prints to the mat board.

14. Place the finished, matted portrait grid in the 16-inch-square frame.

To make using a black-and-white copier:

1. Enlarge or reduce your photograph on the copier so that it is approximately 7 inches square and will center comfortably on an 8½ by 11-inch sheet of paper.

2. After sizing correctly, recopy the print and recopy the copies at 100-percent scale to continue making the prints more grainy and higher in contrast. Experiment with the light/dark and contrast settings on your copier to achieve a

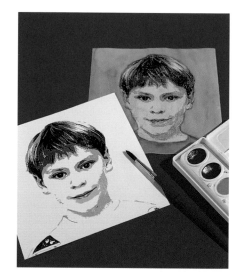

very high-contrast portrait with a white background. When you've created a print you like with the desired effects, it will become your master copy for the watercolor paper.

3. Using the ruler, pencil, X-acto knife, and cutting mat, measure and cut sheets of the watercolor paper to 8½ by 11 inches, allowing at least one sheet for each portrait.

4. Hand feed the paper through the copy machine to make your prints.

5. Using the pencil, ruler, X-acto knife, and cutting mat, measure and trim the prints into 7-inch squares so that each portrait is centered in the same position on the page.

6. Follow steps 10 through 14 above for painting, mounting, and framing the portraits.

Wooden Block Frames

Wooden blocks come in a variety of shapes and sizes and can be assembled and glued together to make decorative photo frames for a child's room. These vintage blocks were found at an antiques store, and we began by experimenting with them in different arrangements to create different-sized frames using the varied shapes. When assembled, the frames can be easily hung on the wall by attaching D-rings and framing wire to the frame backs or by knotting ribbons to the rings as shown, and then hanging them from decorative wall screws.

You will need:

Wooden blocks

Photographic prints

Wood glue

Metal ruler

Two-ply acid-free museum mat board (available at
 art supply stores)

X-acto knife

Pencil

Self-healing cutting mat

8½ by 11-inch sheet .005-thick plastic acetate (available at
 art or drafting supply stores)

Acid-free photo adhesive corners

Drafting tape (available at art or drafting supply stores)

4 small metal turn buttons with screws (also called photo
 anchors, available at hardware and frame stores), or flat-
 top thumbtacks to attach frame back to back of frame

Phillips screwdriver

2 small metal D-rings per frame with ⅜-inch screws
 (available at hardware and frame stores)

Scissors

Framing wire (available at hardware and frame stores)

1 yard ½-inch-wide grosgrain ribbon (optional)

Decorative wall tack (available at hardware and frame stores;
 optional)

To make:

1. Experiment with arranging your blocks until you have a configuration you like that will frame your prints. Here, we used square and rectangular blocks in 2 different arrangements to frame two standard 4 by 6-inch color prints.

2. Using wood glue, carefully glue the blocks together, applying a thin coat of glue to the adjoining block sides and making sure that all the blocks are aligned properly at top and bottom. Let dry completely, about 1 hour.

3. Using the ruler, measure the aperture of the block frame.

4. Measure and cut out a piece of mat board that is at least ¼ inch wider on each side than the frame aperture, using the X-acto knife, ruler, pencil, and cutting mat.

5. Measure and cut out a piece of acetate that is the same size as your photograph, and place it on top of the print.

6. Slide photo corners onto the corners of the print and acetate and position them in the center of the mat board, marking the position of each side with a light pencil mark.

7. Apply moisture to the backs of the photo corners and glue the corners to the mat at the pencil marks.

8. Attach the ends of two 2-inch pieces of drafting tape to the back side of the top of the mat board, leaving 1 inch hanging above the mat. The overhang will be used to help position the mat on the frame.

9. Place the dry block frame over the mounted photo and position the frame so that it is centered over the photo and no white photo borders or photo corners are showing through the aperture.

10. Press the frame against the mat board so that the drafting tape adheres to the blocks.

11. Turn the frame, with the mat, over and position the turn button fasteners on each side of the frame so that they will swivel over each side of the mat when screwed in place. Screw the turn buttons tightly in place with the screwdriver.

12. If using thumbtacks, simply tack the mat board to the wooden frame on all four sides, being careful to insert the tacks into a block and not into a crack between 2 blocks.

13. Remove the drafting tape when finished.

14. Still working on the back of the frame, position the D-ring fasteners to the sides of the frame, slightly above center, and screw each in place with a screwdriver.

15. Using scissors, cut a length of framing wire that is the length of the frame plus 3 inches. Twist the ends of the wire around each D-ring until the wire is taut. Rotate the rings toward the center of the frame, and hang the wire onto a framing hook nailed to the wall.

16. Alternatively, to hang the frame from ribbons, knot the ends of two 18-inch lengths of ribbon onto the D-rings and rotate the rings toward the top of the frame. Tie the loose ends in a bow and hang the frame from a decorative wall tack. (You may need to adjust the length of the ribbons, retie the bow, and trim the ribbon ends with scissors, depending on the height at which you wish to hang the frame from the wall tack or other frames above or below it.)

Wooden Letter Monogram Frame

Large wooden letters are a popular way to personalize a child's bedroom or playroom. Here, we used them to decorate the mat surrounding a photo in a shadow-box frame. You can use a single initial of the child's name or both initials, if desired, as shown. Be aware that the size of the letters you choose will dictate the size of photograph, frame, and mat you will need.

You will need:

2 wooden letters, approximately 5½ inches tall

6 by 8-inch photograph

Pencil

Metal ruler

X-acto knife

Self-healing cutting mat

8-inch-square piece of mat board

White all-purpose craft glue

Acid-free adhesive photo stickers

8-inch-square shadow-box frame (available at frame stores)

To make:

1. Before getting started, lay the wooden letters on top of your photo to determine their position. They should flank the person or persons in the photo on either side. You may need to make an enlarged or reduced copy of your photo in order to frame the subject successfully. If so, make sure your photo is at least 6 inches square so that you will have ample area to attach the photo to the back of the mat later on.

2. Mark the position of the outer edges of each letter on the photo with a light pencil mark.

3. Using the ruler, pencil, X-acto knife, and cutting mat, measure and cut a 5-inch window out of the center of the mat board and discard the center cutout.

4. Lay the wooden letters on top of each side of the mat, positioning them so that they straddle the mat and the window.

5. Mark the position of each letter on the mat with a very light pencil mark at the top, bottom, and each outer side.

6. Remove the letters and place a thin line of craft glue along the edges of the window, inside the pencil marks, where the letters were previously positioned.

7. Lay the letters back on top of the mat, replacing them over the glued areas according to the pencil markings. Let dry about 20 minutes.

8. Lay the mat over the photo so that the photo is framed by the letters again in the position originally determined. If necessary, trim any excess photo that extends beyond the outer edges of the mat using the X-acto knife and ruler.

9. Place an adhesive photo sticker on the front of each corner of the photo and attach the photo to the back of the mat. Insert the finished matted photo into the shadow-box frame according to the frame instructions.

Note: For a letter with curves like the "J" used here, position the letter so that it overlaps the corners of the window, then trim away the edge of the window that protrudes out past the letter with an X-acto knife, using the inside curve of the letter as a trimming guide.

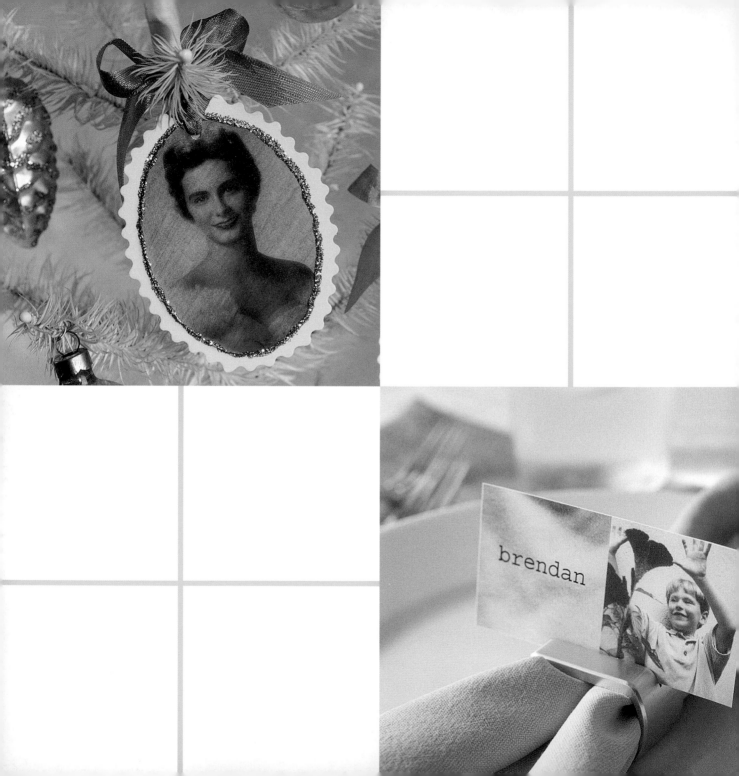

Homeworks

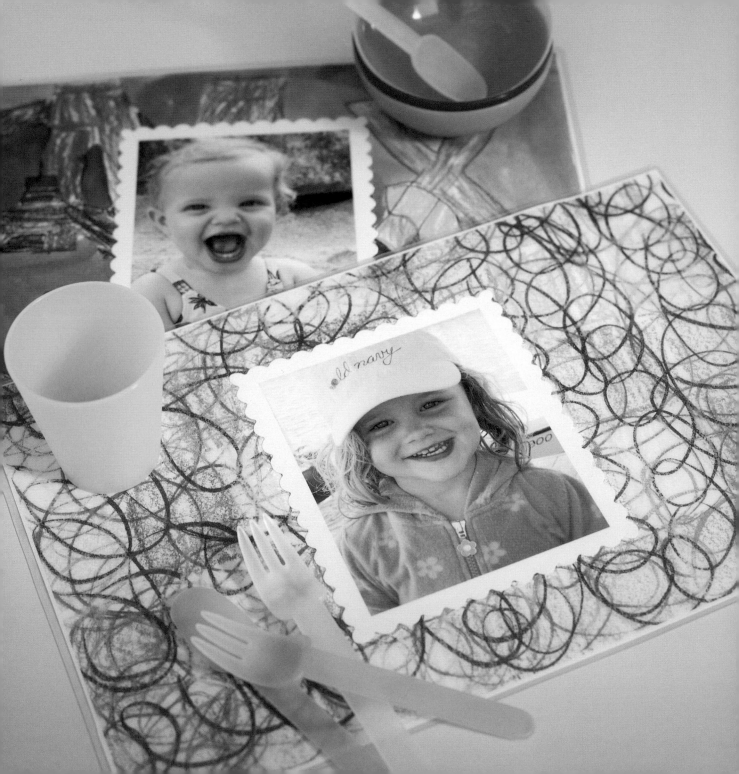

Laminated Photo Place Mats

Make your own festive laminated place mats with favorite family photos and colorful printed papers or your child's artwork. Match photos to paper or artwork whose colors and mood work well together or coordinate with your table décor.

You will need:

Color copier, or personal computer with desktop publishing software, color inkjet printer, and sheets of 8½ by 11-inch inkjet paper

Several 4 by 6-inch photo prints with white borders, or digital scans of family photos

Child's artwork at least 8½ by 11 inches, or colored paper at least 11 by 17 inches

Metal ruler

Pencil

X-acto knife

Self-healing cutting mat

Decorative-edged scissors

Double-stick tape

Laminating machine or laminating services at a copy shop

Scissors

To make:

1. Use a color copier to make enlargements of your 4 by 6-inch photos at 115 percent. Alternatively, use a personal computer and desktop publishing software to enlarge the digital scans to approximately 4¾ by 7 inches, allowing a ¾-inch white border on all sides. Using the color inkjet printer, print out the digital scans on inkjet paper.

2. If using children's artwork for the background, enlarge the artwork to fill an 11 by 17-inch sheet and make a color copy of each piece of art on 11 by 17-inch paper. If using colored paper for the backgrounds, measure and trim sheets to 11 by 17 inches if necessary using the ruler, pencil, X-acto knife, and cutting mat.

3. Using decorative-edged scissors, cut out the color-copy portraits or inkjet prints, leaving at least a ½-inch white border around the photos.

4. Position the portraits in the center of each enlarged color copy of child's art or piece of colored paper and adhere in place with a small piece of double-stick tape under each corner of the portrait.

5. Laminate the place mats yourself with a laminator or take them to a copy shop to be laminated, being sure to leave a ¼-inch margin of laminate around all sides of each mat.

6. Round the corners of the laminated mats with scissors.

7. The place mats are now water- and stain-resistant and can be wiped clean with a damp cloth or sponge after each use.

Photo Place Cards

Create a special table accent for your next family gathering by making a colorful photo place cards for each guest. Choose random photos or create a theme for your occasion by choosing photos that relate to your event. The left-side color panel for the guest's name is created by enlarging an area of detail from the right-side photo on which type will be legible.

You will need (if making with a personal computer):

Personal computer

Desktop publishing software

Digital photographs of each guest

Sheets of 8½ by 11-inch heavyweight inkjet paper
 (glossy or matte)

Color inkjet printer

X-acto knife

Metal ruler

Self-healing cutting mat

Place-card holders (optional)

You will need (if making on a color copier):

Pencil

Metal ruler

Sheets of 8½ by 11-inch white bond paper

Proportion wheel

Photographs of each guest

Color copier

X-acto knife

Self-healing cutting mat

Letter stickers

8½ by 11-inch heavyweight color-copier paper

Place-card holders (optional)

To make place cards using a personal computer:

1. Using a computer and desktop publishing software, create a 2 by 4-inch place card document for each guest.

2. Import a digital photo of each guest onto the right side of each page and crop the photos as desired into 2-inch squares.

3. Select an area of detail within each photo; copy and paste it onto the left side of each page and enlarge into 2-inch squares next to each guest photo. (We used a detail of the child's shirt in the place card shown.) Be sure that the photo detail you have chosen to enlarge for the left-hand squares will allow the typed name to be legible when placed on top of it. Photos and details should butt together in the center.

4. Type each person's name on the left square. (We used 22-point Courier type.)

5. When ready to print, select crop marks in your print menu and print out the finished place cards on heavyweight inkjet paper using a color inkjet printer.

6. Trim out the place cards with the X-acto knife, ruler, and cutting mat using the crop-mark guides. Insert the trimmed cards into place-card holders on your table or set them at each guest's place setting.

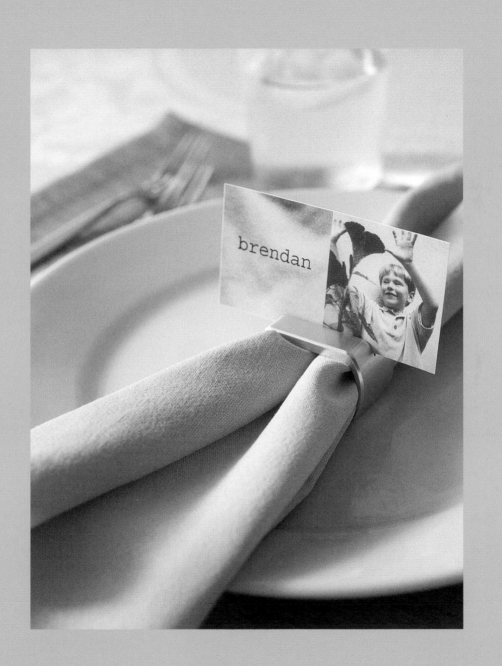

Photo Place Cards (continued)

To make place cards using a color copier:

1. Make a place-card template: Using a pencil and ruler, lightly draw a 2 by 4-inch rectangle on a sheet of bond paper. Repeat for each guest.

2. Determine how you want to crop the guest photo for the right-side squares using strips of bond paper to form a square around the image.

3. Using the ruler and proportion wheel, determine the size of enlargement or reduction of the photo so it will fit inside a 2-inch square.

4. Going back to your original guest photo, select an area of detail in the photo to enlarge for your left-side squares.

5. Using the ruler and proportion wheel again, determine the size of enlargement of the area of detail so it will fit inside a 2-inch square.

6. Repeat for each guest.

7. Make 2 color copies of each photo at the different predetermined percentages.

8. Trim the copies into 2-inch squares with the X-acto knife, ruler, and cutting mat.

9. Match guest photo right-side squares with area-of-detail left-side squares. Glue them side-by-side on each place-card template page with a glue stick on top of the penciled guidelines.

10. Using letter stickers, spell out each guest's name inside the left-side square.

11. Make a final copy of each place-card template on heavyweight color-copier paper and trim out the copies using the X-acto knife and ruler.

12. Insert the trimmed cards into place-card holders on your table or set them at each guest's place setting.

Hand-Colored Photo Ornaments

Use color copies of old family portraits to create these unique paper ornaments to decorate your Christmas tree. Color them with colored pencils, write each person's name and birthdate on the back, and tie to tree branches with soft pastel ribbons for an heirloom "family tree."

You will need:

Color copier

Metal ruler

Proportion wheel

Black-and-white family photographs

Small Post-it notes

Pencil

Colored pencils (available at art supply stores)

Soft facial tissues for blending pencil shading

Large plastic circle and oval templates or stencil film
 (available at craft supply stores)

Scissors

X-acto knife

Self-healing cutting mat

Large sheet of two-ply acid-free 100-percent rag mat board
 in warm white (available at art supply stores)

Spray adhesive

Decorative-edged scissors

All-purpose craft glue

Silver glitter glue (available at craft supply stores)

⅛-inch-diameter hole punch

⅝-inch-wide rayon seam-binding ribbon (several yards
 in assorted pastel colors, cut into 18-inch lengths;
 available at fabric stores)

Silver gel pen (available at art and office supply stores)

To make:

1. Make a black-and-white copy of the templates on page 108 at 200 percent on the copy machine.

2. Using the templates, ruler, and proportion wheel, determine how much you will need to reduce or enlarge your photos on a copy machine to fit the inner dimension of each template.

3. Tag each photo on the back with a Post-it note indicating the percentage to be copied before using the copier.

4. Adjust the color settings on the color copier to copy the photos in black-and-white with an antique sepia tone and, if available, select a multi copy-per-sheet setting so that you will end up with several copies of each photo on a sheet. Select the percentage of reduction or enlargement and make at least 2 copies of each photo to color and experiment with later. (You can adjust the darkness and contrast of the copier settings to achieve different value and contrast effects when copying the photos.)

5. Hand color the photocopies with colored pencils by lightly shading the entire photo with dark pencil colors such as blue, green, purple, brown, or dark red.

6. Blend the pencil shading until it is smooth and no pencil lines are showing by rubbing the photocopies all over with a facial tissue, using firm pressure. You can add spot colors to the photos for added effects using brighter pencil colors.

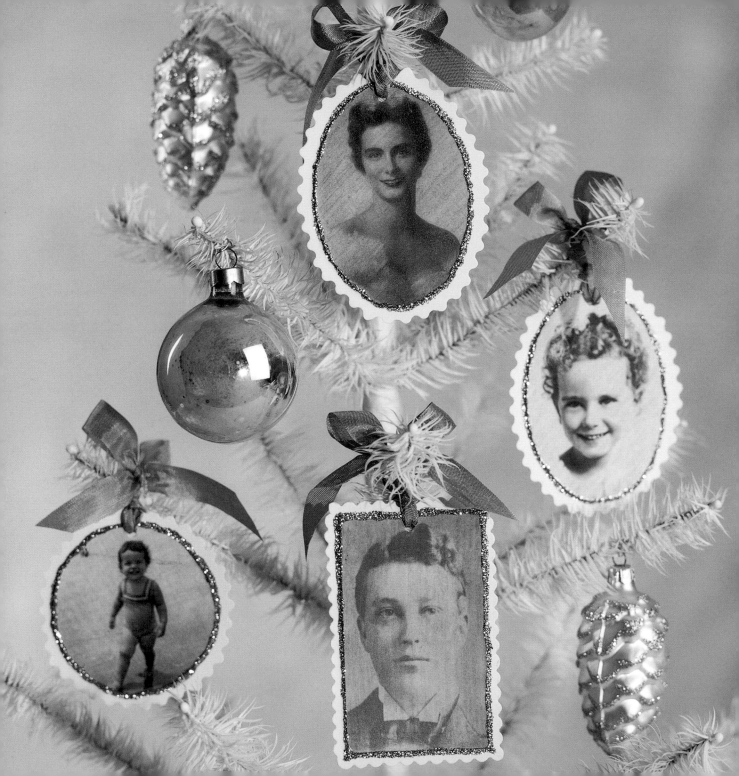

7. Using the plastic circle or oval templates and a ruler for the squares and rectangles, draw a cutting guideline on each photocopy with a pencil, using the templates on page 108 again as a sizing guide (use the inner dimension of each template).

8. Cut out the photocopies with scissors, leaving a border of about ¼ inch around the penciled cutting guidelines.

9. Using the ruler, pencil, X-acto knife, and cutting mat, cut the mat board crosswise into multiple 3½-inch-wide strips.

10. In a well-ventilated room, spray the backs of all the photos with adhesive and mount them on some of the mat board strips without overlapping any of the photos.

11. Carefully trim along the penciled cutting guidelines using scissors or the X-acto knife and ruler.

12. To make the decorative ornament frames, use the outer dimension of each template on page 108 as a sizing guide. Use a same-size plastic template for the circles and ovals or a ruler for squares and rectangles and draw very light cutting guidelines on the remaining mat board strips with a pencil.

13. Cut out the shapes from the strips with decorative-edged scissors along the penciled guidelines.

14. To assemble the ornaments, apply a thin coating of craft glue to the backs of the mounted photos and center them inside each decorative frame.

15. Apply a line of glitter glue along the outer edge of the photos and let the ornaments dry completely.

16. Punch a hole near the top of each ornament with the hole punch and thread with a length of ribbon.

17. Using a gel pen, write the family member's name on the back of his or her ornament and add a birthdate or where and when the photo was taken, if desired.

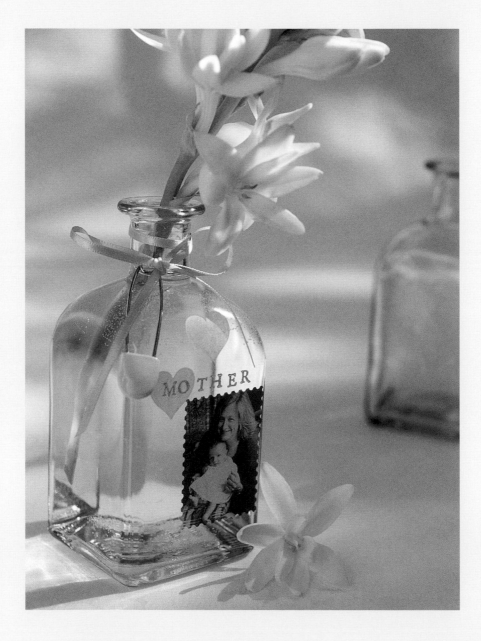

Photo-Collage Vase

This photo-collage vase is an easy-to-make gift for many occasions, such as birthdays, Valentine's Day, or baby showers. Here, we chose a Mother's Day theme using a photo of a mother and child, a ribbon and diaper pin accent, and the word "Mother" stamped on the bottle with alphabet stamps and colored stamping powder. You can use any favorite color or black-and-white photo and change the color to a tinted halftone for an added effect, as shown here. Add the recipient's favorite flower and surprise her on her special day.

You will need:

Photographic print or digital photograph

Small bottle, washed and dried well

Ruler

Color copier, or personal computer, Adobe Photoshop
 software, and color inkjet printer

Proportion wheel (if using a color copier)

Matte-coated, lightweight (27-pound) color inkjet paper
 (if using a personal computer)

Decorative-edged scissors

Spray adhesive

Vellum heart and letter stickers (available at craft and
 scrapbook supply stores)

Rubber letter stamps (optional)

Colored stamping powder (available at craft and
 scrapbook supply stores; optional)

Transparent ink stamp pad (available at craft and
 scrapbook supply stores; optional)

Small, soft-bristle paintbrush (optional)

½ yard ⅛-inch-wide satin ribbon

Diaper pin (available at drugstores)

Scissors

Fresh flowers

To make:

1. Choose a favorite photograph. Measure the photo and the side of the bottle with a ruler to determine how large you want your photo to be.

2. If using a color copier, determine the reduction or enlargement you need using the proportion wheel.

3. If you want to change the color of your photo, adjust the color settings on the copier to print the image in a single color (blue, pink, green, sepia, black-and-white, etc.), and make test prints until you have a color effect you like.

4. Make several final copies of your photo at the correct size.

5. If using a personal computer, size and crop your digital photo using Adobe Photoshop software so that it fits on the side of your bottle.

6. If you want to change the color of your photo, convert the image in Photoshop to one color. Experiment with the contrast and brightness of the image for different effects.

7. Make multiple copies of the image on your document page, and make a print of your photos using the color inkjet printer paper.

8. Trim one of the color photocopies or inkjet prints with decorative-edged scissors and spray the back of the print with spray adhesive.

9. Position the print on the side of the bottle as desired.

10. Add vellum heart and letter stickers to spell out words.

11. Alternatively, you can stamp out words or names using rubber letter stamps, the transparent ink stamping pad, and colored stamping powder, as shown in the photo on page 88.

12. To stamp a word, stamp the letters in transparent ink on the bottle in the desired position. Using a soft paintbrush, lightly brush a small amount of stamping powder over the words, then brush away the excess powder and allow the lettering to dry completely before handling.

13. Finish by tying the ribbon around the neck of the bottle, threading it through the diaper pin and tying the ends in a bow.

14. Trim the ribbon ends with scissors to the desired length.

15. Carefully fill the bottle with water and add the recipient's favorite flower.

Note: The collage artwork will not be waterproof when finished, so avoid getting the outside of the bottle wet. When filling the bottle with water, do so carefully using a funnel or a cup or pitcher with a spout.

Photo Desk Calendar

Select 12 of your favorite family photos, one for each month of the year, to create this simple photo desk calendar. When selecting photos, choose photos that have an empty area in one corner for the calendar grid. The finished calendar cards, created with either a color copier or personal computer, are loaded into a plastic jewel case that becomes a desktop easel calendar when opened.

You will need (if making with a personal computer):

Personal computer

Desktop publishing software

12 digital photo scans

Current calendar

8½ by 11-inch heavyweight inkjet paper (glossy or matte)

Color inkjet printer

X-acto knife

Ruler

Self-healing cutting mat

Plastic calendar jewel cases (see Resources, page 110)

You will need (if making on a color copier):

8½ by 11-inch bond paper

Pencil

Ruler

X-acto knife

Self-healing cutting mat

5 by 7-inch color photo prints

Double-stick tape

Current calendar with mini calendar grids included at the bottom of each month or on the inside covers

Proportion wheel

Black-and-white and color copiers

Clear copier film (available at office supply stores)

Heavyweight color copier bond paper

Plastic calendar jewel cases (see Resources, page 110)

To make desk calendar using a personal computer:

1. Create a 4⅝ by 5½-inch, 12-page calendar document using a personal computer and desktop publishing software.

2. Import a digital photo scan to each page and enlarge and crop the photos to the page dimensions as desired.

3. Scan the calendar type template on page 108, import it into your calendar document, and use it as a template to create a monthly calendar grid for each page of your document. You can position the calendar grid anywhere on the page where it looks best or is most legible on the photo, but leave at least a ¼-inch margin at the top and side edges and a ⅝-inch margin at the bottom of the page.

4. Use a current calendar as a reference when placing numbers on the correct days of the week for each month.

5. Select a typeface and type color as desired, making sure the type is legible over each photo. (We used 18-point Univers 55 for the month type and 8-point Univers 65 Bold for the days of the week and numbers.)

6. Delete the calendar type template after your type is set.

7. Print out the finished calendar pages on heavyweight inkjet paper on a color inkjet printer, being sure to select crop marks in your print menu before printing.

8. Trim the calendar pages with the X-acto knife, ruler, and cutting mat using the crop mark guides.

9. Insert the cards into the plastic jewel case chronologically.

To make desk calendar using a color copier (see note):

1. Make 12 calendar page templates by lightly drawing a 4⅝ by 5½-inch rectangle on 12 sheets of white bond paper with the pencil and ruler.

2. At each rectangle corner, draw a small, dark pencil line approximately ¼ inch long and perpendicular to each side. You should have 2 lines each at corner. These will become the trimming guides after making your color copies later on.

3. Using the ruler, X-acto knife, and cutting mat, cut your 5 by 7-inch photo prints down to 4⅝ by 5½ inches, cropping the sides or top and bottom as desired.

4. Position the photos within the pencil-drawn rectangles on the 12 sheets of bond paper, adhering each photo with double-stick tape.

5. Using a current mini calendar for each month, determine the percentage of reduction or enlargement of the month grids with a ruler and proportion wheel. Your month grids should be approximately 1⅝ inches square.

6. Using a copy machine, make a finished, correctly sized copy of each calendar month grid on clear copier film.

7. Lay a film month grid on top of each photo page template, positioning the calendar on the photo where it is most legible.

8. Tape each film month grid in place outside the rectangular perimeter with double-stick tape.

9. Make color copies of each photo page template on a color copier using heavyweight color copier paper.

10. Trim the calendar cards with the X-acto knife, ruler, and cutting mat, using the dark pencil guide marks as trim guides.

11. Insert the cards into the plastic jewel case chronologically.

Note: If you are making the calendar on a color copier, you will need to select photos that have light backgrounds so your black-type overlays will be legible in the area where you position them.

Photo Cachepots

Create these rustic, photo-decorated cachepots to hold an array of tabletop tools such as pens and pencils or cooking utensils. Cluster several different-sized pots together in a unique utilitarian display of your favorite family photos.

You will need:

Terra-cotta pots in various small shapes and sizes

12-inch-square piece of black felt

Pencil

Scissors

All-purpose craft glue

Ruler

Proportion wheel

Family photos

Black-and-white or color copier

Decorative-edged scissors

Small foam brush

Mod Podge découpage water-based sealer, matte finish

Rubber letter stamps and ink pad

To make:

1. Make sure the clay pots are clean and dry.

2. Place the bottom of each pot on the felt square and trace the bottom onto the felt with a pencil.

3. Cut out the felt shapes with scissors and apply craft glue around the entire edge of each shape.

4. Attach the felt to the bottoms of the pots and allow the glue to dry completely, about 30 minutes.

5. With the ruler and proportion wheel, determine the percentage of enlargement or reduction necessary to make copies of your family photos that will fit comfortably on the sides of the pots below the rims.

6. Using a copy machine, make copies of the photos at the predetermined sizes.

7. Cut out the photocopies with decorative-edged scissors, leaving a 1/8- to 1/4-inch border on all sides.

8. Using the foam brush, apply a coat of Mod Podge sealer to the back of the photocopies and affix them to the sides of the pots.

9. Press the photocopies against the sides of the pots with your fingers, working out any air pockets that may have formed.

10. Apply another coat of Mod Podge over the copies, being sure to brush the sealer over the copy edges as well. Let dry completely, 15 to 20 minutes.

11. With the rubber letter stamps and ink pad, stamp the initial of your family name or other words onto the rims of the pots above the photocopies and let dry.

12. Fill the pots with pencils, desk accessories, kitchen tools, or other everyday tools you want to keep on hand.

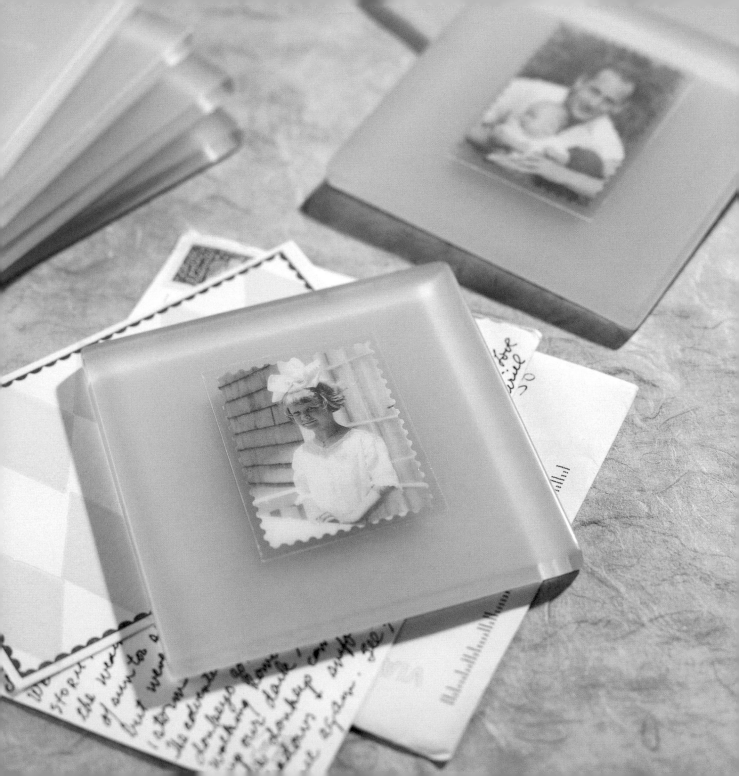

Photo Tile Paperweights

These tile paperweights are easy to make and are a terrific gift for someone special. Use remnant tiles from a tile supply company or buy a single type of tile by the square foot, as we did. Be sure to bring along your photos when selecting tiles so that you can coordinate the colors and style of your photos and tiles.

You will need:

Ruler

Proportion wheel

Color copier, or personal computer and color inkjet printer

Photographic prints or digital photographs

Decorative-edged scissors

Small foam paintbrush

Diamond Glaze brand water-based dimensional adhesive
 (available at craft- and scrapbook-supply stores)

4-inch-square glass or ceramic tiles

6-inch-square piece of plastic wrap

Burnisher (available at art-supply stores)

¾-inch-wide masking tape

Soft-bristle paintbrush

To make:

1. With the ruler and proportion wheel, determine the percentage of enlargement or reduction necessary to make copies of your photographs to fit on the 4-inch-square tile, allowing at least a 1-inch border of tile on all sides.

2. Using a color copier or personal computer and color inkjet printer, make copies of your photos at the predetermined sizes. (We made our photos 2 by 2½ inches.) If using a color copier, you can adjust the color and light/dark settings to give your photos an antique or faded look, if desired.

3. Cut out the color copies or inkjet prints with decorative-edged scissors.

4. Using the foam brush, apply a light, even coat of dimensional adhesive to the back of each print. Stick a print face up in the center of each tile.

5. Place the plastic wrap over a print and, using the burnisher, gently burnish the print to remove any air pockets between the print and the tile. Repeat for all the tiles, then discard the plastic wrap.

6. Using strips of masking tape, create tape frames around all the prints, leaving a ⅛-inch margin of tile around all sides of the prints. Gently burnish the edge of the tape frame closest to the print to ensure a securely masked seal. Repeat for all the tiles.

7. Squeeze a small amount of adhesive (about the size of a quarter) onto a print and spread it over the entire area inside the tape frame, using the soft-bristle brush. Repeat for all the tiles and allow the adhesive to dry completely, about an hour.

8. To finish, gently remove the tape frames, starting with the strips on the topmost layer, and pulling them away from the adhesive-covered prints.

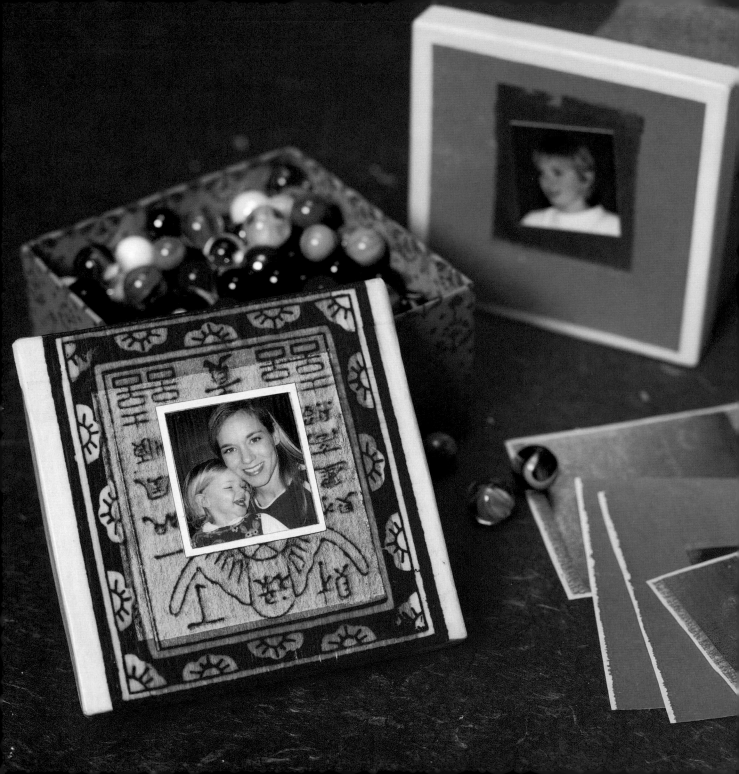

Découpage Photo Keepsake Boxes

Brightly colored Chinese joss paper was the inspiration for these decorative photo keepsake boxes. Joss paper comes in inexpensive packages found in Asian markets and variety stores around the world. We chose photos whose colors complemented the paper colors to découpage to the box lids. Because découpage sealer dries clear, it is the perfect adhesive and sealing medium for the delicate paper, also allowing the gold-leaf designs to shine through.

You will need:

Assorted packages of Chinese joss paper (available in Asian markets and variety stores)

4½ by 4½ by 2⅝-inch cardboard boxes with lids (available at craft supply stores)

Scissors

Aluminum foil tray or sheets of aluminum foil

Mod Podge découpage water-based sealer, matte finish (available at craft supply stores)

Small foam brush

Burnisher

Paper towels

12-inch-square sheet of coordinating colored paper for the box bottoms (optional)

X-acto knife

Ruler

Self-healing cutting mat

Small photographic prints or color copies

To make:

1. Starting with the box lid, experiment with different designs of joss paper to determine how you want to decorate your box. Cut out parts of the paper with scissors or use whole sheets as desired. When ready to apply paper and sealer, work on an aluminum foil tray or a large sheet of aluminum foil.

2. Coat the box lid and sides with Mod Podge, using the foam brush.

3. Apply joss paper pieces according to the design you've determined, folding the paper around the sides of the lid and over the edges to the underside of the lid.

4. To wrap the corners, cut the paper perpendicular from the edge to each corner with scissors so that tabs can wrap around the corners and side flaps can fold over tabs. You will need to apply a little sealer on top of the tabs so that the side flaps will adhere to the tabs.

5. Turn the lid upside down on a clean area of the work surface and, using the burnisher, firmly burnish the underside of the lid to eliminate air pockets between the paper and the lid. Let the lid dry for about 15 minutes.

6. Turn the lid right side up and coat the top and sides with Mod Podge sealer. Ink colors on joss paper will bleed when moistened, so do not brush over the printed areas of the paper more than once per coat to avoid smearing ink. If the ink bleeds onto the brush, simply rinse the brush in water and wring out the excess water with paper towels between strokes. Let the coat of sealer dry completely, about 30 minutes.

7. When the first coat is dry, the joss paper inks will be sealed and you can apply 2 to 3 more overcoats of Mod Podge without smearing the inks, letting each coat dry for about 30 minutes.

8. For the bottom of the box, repeat the process of wrapping and adhering paper around the sides, over the top edges, and onto the bottom.

9. After wrapping the sides, cut out a square of coordinating colored paper the same size as the bottom panel of the box using the X-acto knife, ruler, and cutting mat.

10. Apply sealer to the box bottom and press the box to the paper, burnishing from inside the box bottom as before to eliminate air pockets. Let the bottom dry for about 15 minutes.

11. Repeat the process of applying and drying the sealer, and the additional 2 or 3 overcoats, as described in steps 6 and 7.

12. To finish, trim the photo to the desired size with the X-acto knife and ruler and adhere it to the lid with sealer. Let dry, then coat the photo and the entire lid of the box with one more layer of sealer. Allow it to dry completely before handling, about an hour.

Templates

Birthday Invitation Sticker Template

Birthday Invitation Sticker Template is at 50% of original size;
enlarge on copier at 200% to fit on 8½ x 11-inch label paper

Family Moving Announcement Templates

fold here

fold here

House Front

Windows

Family Moving Announcement Templates are at 50% of original size;
enlarge on copier at 200%

Holiday Photo CD Card Template

fold here

fold here

fold here

Holiday Photo CD Card Template is at 50% of original size;
enlarge on copier at 200%

Pull-out Photo Valentine Templates

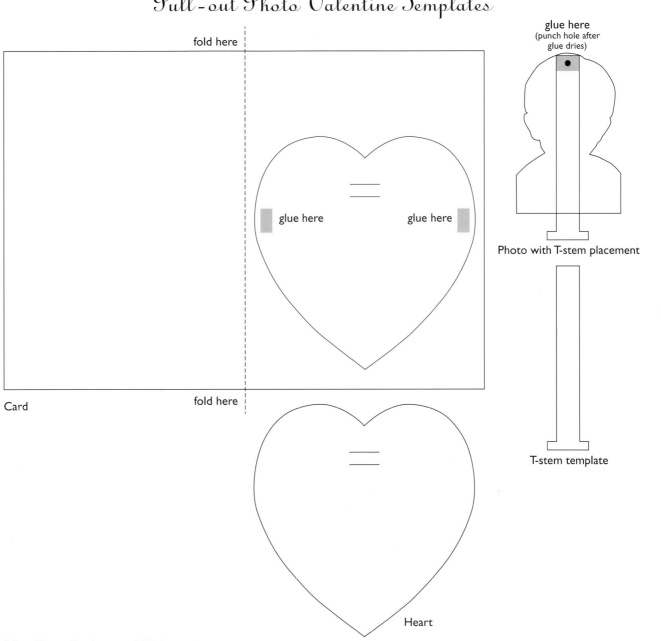

fold here

glue here
(punch hole after glue dries)

glue here glue here

Photo with T-stem placement

fold here

Card

T-stem template

Heart

105

Pull-out Valentine Templates are at 50% of original size;
enlarge on copier at 200%

Portrait Note Cards Template

Portrait Note Cards Template is at 50% of original size;
enlarge on copier at 200% to fit on 8½ x 11-inch label paper

Ribbon-Covered Frame Templates

A

Frame Back and Front

(note: frame back does not have cut-out window)

C

Frame Easel Leg

B

Frame Photo Pocket

glue along edges
as indicated by
dark strips

Ribbon-Covered Frame Templates are at 50% of original size;
enlarge on copier at 200%

Hand-Colored Photo Ornament Templates

Hand-Colored Photo Ornament templates are at 50% of original size;
enlarge on copier at 200%

Photo Desk Calendar Type Template

July

S	M	T	W	T	F	S
					1	2
3	4	5	6	7	8	9
10	11	12	13	14	15	16
17	18	19	20	21	22	23
24	25	26	27	28	29	30/31

October

S	M	T	W	T	F	S
2	3	4	5	6	7	1/8
9	10	11	12	13	14	15
16	17	18	19	20	21	22
23	24	25	26	27	28	29
30	31					

Photo Desk Calendar Type Template is at full size,
copy at 100%

Resources

Photo Birth Announcement (p. 17):
⅛-inch-diameter hole punch by Fiskars; ribbon flowers from Buttons & Bows, San Anselmo, CA, 415-453-5080.

Birthday Invitation (p. 19): Ladybug and dragonfly stickers by Mrs. Grossman's, 800-429-4549, www.mrsgrossmans.com; butterfly sticker from the "Anna Griffin" sticker collection, grasshopper from The Gifted Line, John Grossman Inc., both available at Attic Archives, Corte Madera, CA, 415-945-9980; 1-inch-diameter circle punch by EK Success Paper Shapers Paper Punches, www.eksuccess.com, available at The Scrapbook Place, Houston, TX, 713-838-2767, www.txscrapbook.com; "Antique Lowercase Alphabet" by PSX Design, www.addictedtorubberstamps.com.

Family Moving Announcement (p. 22): Key-shaped craft punch by Marvy, available at The Scrapbook Place, Houston, TX, 713-838-2767, www.txscrapbook.com.

Photo Pocket Card (p. 25): ¹⁄₁₆-inch-diameter hole punch by Fiskars; waxed twine available at Hobby Lobby, stores nationwide, 800-323-9204, www.hobbylobby.com, and Attic Archives, Corte Madera, CA, 415-945-9980.

Holiday Photo CD Card (p. 27): Rubber letter stamps, "Antique Lowercase Alphabet" by PSX Design, www.addictedtorubberstamps.com; rubber snowflake stamp by All Night Media, www.allnightmedia.com; gray stamp pad by Impress, 206-901-9101, www.impressrubberstamps.com; embossing stamp pad by Top Boss, www.clearsnap.com, clear and silver embossing powder by Stamp-n-Stuff, all available at Hobby Lobby, stores nationwide, 800-323-9204, www.hobbylobby.com; embossing heat tool by Marvy Uchida, available at Michael's Arts and Crafts, stores nationwide, 800-642-4235, www.michaels.com; silver thread by Kreinik Metallics, available at Hobby Lobby; CD labels by Avery, Item No. 8692, available at Office Depot, stores nationwide, 800-463-3768, www.officedepot.com.

Pull-out Photo Valentine (p. 29): ⅛-inch-diameter hole punch by Fiskars; ⅛-inch-wide satin ribbon available at Jo-Ann Fabrics & Crafts, www.joannfabrics.com.

Portrait Note Cards (p. 33): 8½ by 11-inch white laser printer labels from Avery, Item No. 365466; rubber letter stamps from Impress, www.impressrubberstamps.com; letter stickers by Creative Imaginations, available at Hobby Lobby, stores nationwide, 800-323-9204, www.hobbylobby.com..

Folding Keepsake Growth Chart (p.35): "Wheat" color heavyweight paper by Canson Colorline; tape measure ribbon from The Ribbonerie, San Francisco, CA, 415-626-6184, www.theribbonerie.com; "Scallop" decorative-edged scissors by Fiskars Paper Edgers.

Photo Gift Tags (p. 39): Printed seam binding ribbon by Midori, www.midoriribbon.com, available from Buttons & Bows, San Anselmo, CA, 415-453-5080.

Vacation Photo Album (p. 43): PVA bookbinding glue, www.BookByHand.com, available at art- and scrapbook-supply stores; map from U. S. Geological Survey, 1-888-ASK-USGS, www.store.usgs.gov; "Long Deckle" decorative-edged scissors by Fiskars Paper Edgers; rubber stamps by Fred B. Mullett, 206-624-5723 or www.fredbmullett.com, available at Attic Archives, Corte Madera, CA, 415-945-9980.

Photo Bookplates (p. 46): 8½ by 11-inch white laser printer labels from Avery, Item No. 365466; "Antique Lowercase Alphabet" rubber letter stamps by PSX Design, available from www.addictedtorubberstamps.com; "Pinking" decorative-edged scissors by Fiskars, available at Michael's Arts and Crafts, 800-642-4235, www.michaels.com.

Photo Booth Bookmarks (p. 49): Alphabet beads by Crafts, Etc., www.craftsetc.com, available at Hobby Lobby, stores nationwide, 800-323-9204, www.hobbylobby.com.

Family Who's Who Book (p. 51): 1½-inch-diameter circle punch by EK Success Paper Shapers Paper Punches, www.eksuccess.com, available at The Scrapbook Place, Houston, TX, 713-838-2767, www.txscrapbook.com; colored heavyweight paper by Canson Colorline.

Photo Frame Pins (p. 57): Miniature gold frames by Decorative Details, www.nunndesign.com, 360-379-3557, available at Attic Archives, Corte Madera, CA, 415-945-9980; Diamond Glaze brand water-based dimensional adhesive by Judi-Kins, www.judikins.com; brass sheeting by K&S Engineering Co., Chicago, IL; Bond 527 multipurpose cement.

Decorative Photo Magnets (pp. 58): Lucite magnets by Dennis Daniels and Burnes; Bond 527 multipurpose cement; Italian shirt buttons from Buttons & Bows, San Anselmo, CA, 415-453-5080.

Ribbon-Covered Frames (p. 60): Terrifically Tacky Tape, double-sided tape sheets by Art Accents & Provo Craft, www.provocraft.com; Just the Pieces easel-back photo frame kits by Books by Hand, available at Attic Archives, Corte Madera, CA, 415-945-9980; ribbons from Buttons & Bows, San Anselmo, CA, 415-453-5080.

Fabric-Covered Frames (p. 63): Oil-board lettering stencil sets by Duro Decal Company; 5 by 7 by ½ -inch canvas frames by Master's Touch, both available at Hobby Lobby, stores nationwide, 800-323-9204 or www.hobbylobby.com.

Découpaged Paper-Covered Frames (p. 67): Canvas-covered frames by Fredrix-Gallery Wrap Artist Canvas, available at Texas Art Supply, Houston, TX, 800-888-9278 or www.texasart.com.

Map Mats (p. 69): Map from U.S. Geological Survey, 1-888-ASK-USGS, or www.store.usgs.gov; "Long Deckle" decorative-edged scissors by Fiskars Paper Edgers.

Hand-Painted Photo Portraits (p. 71): Lightweight watercolor pads by Mead, available at art and office supply stores; children's boxed watercolor sets by Crayola or Prang.

Wooden Block Frames (p. 73): Wooden blocks from The Cottage Antiques, Fairfax, CA, 415-388-0885; ribbon from Buttons & Bows, San Anselmo, CA, 415-453-5080; turn buttons (photo anchors) and D-ring frame hardware from Creative Merchandise, San Rafael, CA, 415-453-7346, and Paper Zone, stores in Washington, Oregon, and California, www.paperzonecalifornia.com.

Wooden Letter Monogram Frame (p. 77): Wooden letters by Twelve Timbers, available from A Child's Delight, stores in the San Francisco Bay area, www.achildsdelight.com; "Scrapbook Page Frame" by North American Enclosures, available at Aaron Brothers, 1-888-FRAMING or www.aaronbrothers.com.

Photo Place Cards (p. 82): Place-card holder/napkin rings from IKEA, stores nationwide, 1-800-434-4532, www.IKEA.com.

Hand-Colored Photo Ornaments (p. 85): "Wave" decorative-edged scissors by Fiskars Paper Edgers; colored pencils by Prismacolor or DerWent brands; glitter glue by Sparkles, www.psxdesign.com.

Photo-Collage Vase (p. 89): "Stamp" decorative-edged scissors by Fiskars Paper Edgers; vellum heart stickers by Mrs. Grossman's, 800-429-4549 or www.mrsgrossmans.com; "Printer's Type" rubber letter stamps by Hero Arts, No. LL761, www.heroarts.com; watermark stamp pad by Versa Mark, www.tsukineka.com; "Duo Green-Yellow" stamping powder by Pearl Ex, Jacquard Products, 800-442-0455 or www.jacquardproducts.com; diaper pins by Gerber.

Photo Desk Calendar (p. 91): Plastic calendar jewel cases available from Uline Shipping Supplies, 1-800-958-5463, www.uline.com.

Photo Cachepots (p. 95): Weathered French flowerpots from In the Garden, Houston, TX, 713-932-7652, www.inthegarden.com; "Anna Griffin" rubber letter stamps by All Night Media, available from www.allnightmedia.com and at Michael's Arts and Crafts, stores nationwide, 800-642-4235, www.michaels.com.

Photo Tile Paperweights (p. 97): "Chalk Satinato" glass tile by Contemporanea, available at Italics, Emeryville, CA, 510-547-1877; Diamond Glaze brand water-based dimensional adhesive by Judi-Kins, www.judikins.com; "Stamp" decorative-edged scissors by Fiskars Paper Edgers.

Découpage Photo Keepsake Boxes (p. 99): Mod Podge matte-finish sealer by Plaid Enterprises, Norcross, GA, 1-800-842-4197, www.plaidonline.com.

Acknowledgments

The author would like to extend heartfelt thanks and appreciation to the following individuals for their help in making this book:

To my project codesigner, Leslie Barry, for her many brilliant ideas, hard work, and beautiful project contributions; to Caroline Kopp, for her talented photographic eye and easy-going nature and her photography assistant Will Taylor; to my friend and assistant Kristen Wurz, for her expert design production help on this and every project we do together; to Lorena Jones who conceived of the book, Kirsty Melville, and Julie Bennett at Ten Speed Press, all of whose inspiration and guidance in bringing this book to life have been invaluable; and to my husband and son for supporting my crafting obsession and the mess it creates!

The following families lent us their photos and their time for the project, and I am so grateful that they wanted to be part of the book: the Barry, Johnson, Sela, Todd, Waddell, Knuth, Wurz, Michon, Hallanan-Doyle, Brickman, Cain, Cook, Dickerson, Jasper, Miller, O'Malley, Stehr, Weaver, and Ward families.

I would also like to thank the many individuals who lent their expert technical advice on materials or processes: Toni Bird Jones of Avatar Business Services; Donna Garrett of Attic Archives; Elizabeth De Scala of Buttons & Bows; Tom Johnson, computer systems advisor; Whitney Werner; and Edmond Hakin of Photo Sprint, Mill Valley, CA.